THE AMERICAN WEST

COLORING BOOK

chartwell books

Capture the beauty and excitement of the western frontier with *The American West Coloring Book*!

IF you've ever dreamed of riding through the sun-soaked Great Plains of the American West, or you simply enjoy the relaxation coloring can provide, you'll buck-up at these majestic illustrations that bring the excitement and adventure of the western frontier to your fingertips. Known for its rugged mountain ranges, radiant valleys, and the buzzing thrill of opportunity, the western world unfolds in these pages through stunning images of sharp-shooting cowboys, wild horses, rolling landscapes, and daring cowgirls.

Just as there is no right or wrong way to use this book, there is no right or wrong way to bring these pages to life! Relax into the scenes from pioneer life and make them as realistic or creative as you wish. Fiery oranges, deep greens, or rich browns, the choice is yours! One of the great things about coloring is that it's accessible to anyone. Whether you're an experienced artist or just starting out, you can create vibrant, finished pieces of art in whatever way you'd like. Unlock your inner artist and use your imagination to bring the exhilarating world of the west to life with your own unique touch.

With more than 120 line-drawn designs on the back of each page to color, you'll enjoy hours of stress-free fun. Unwind and get in touch with your creative side as you color your way through the striking designs and illustrations that transport you to the exciting world of the American West.

So, what are you waiting for? Lasso your crayons and get coloring!

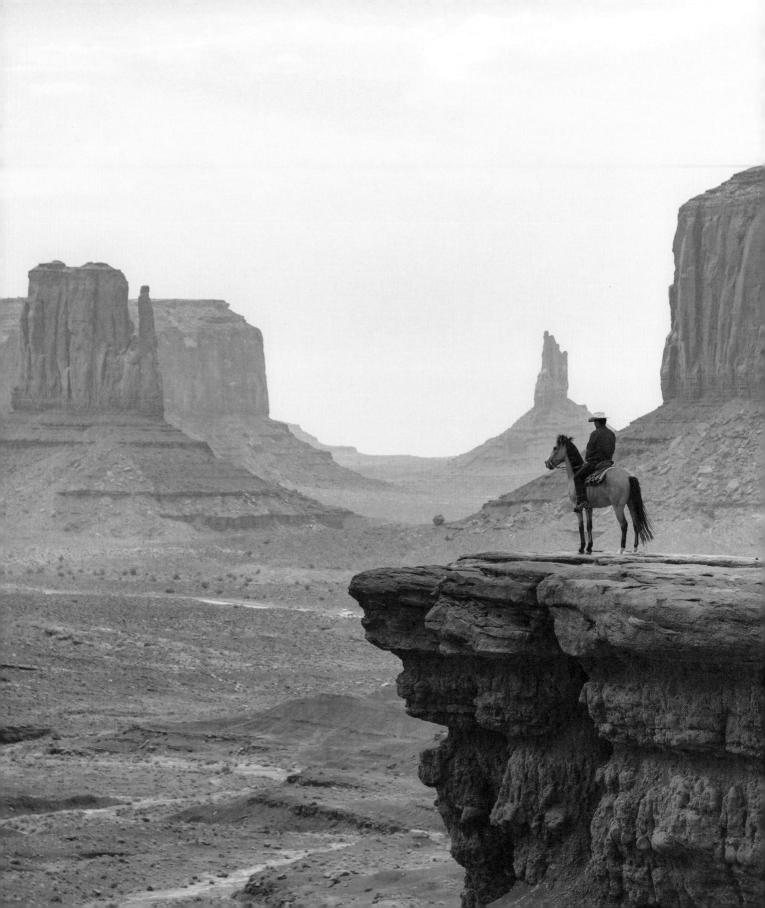

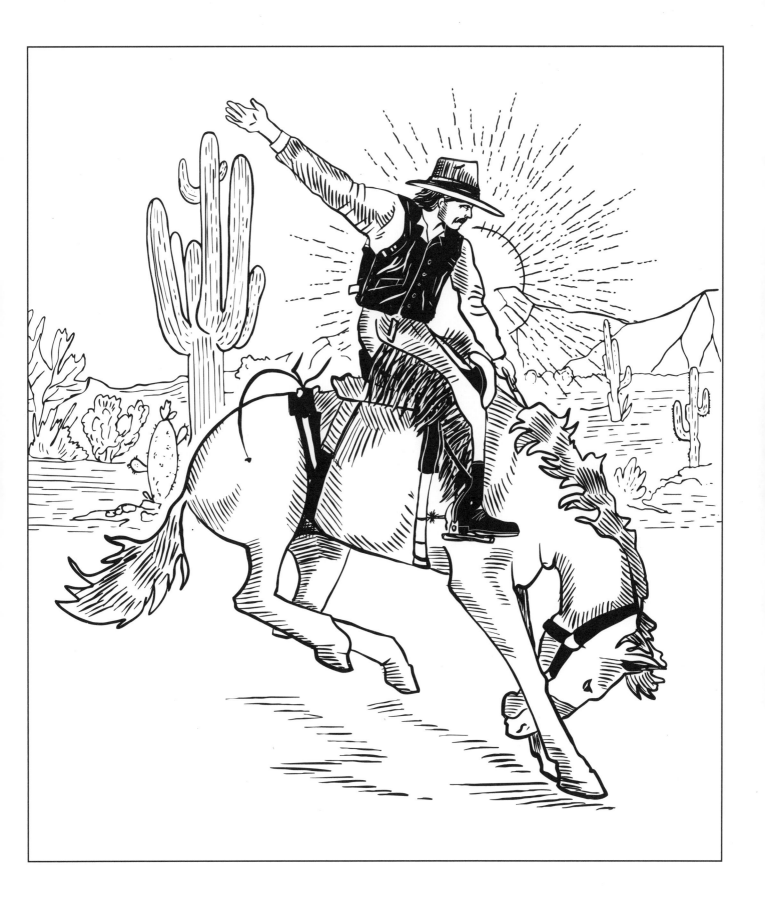

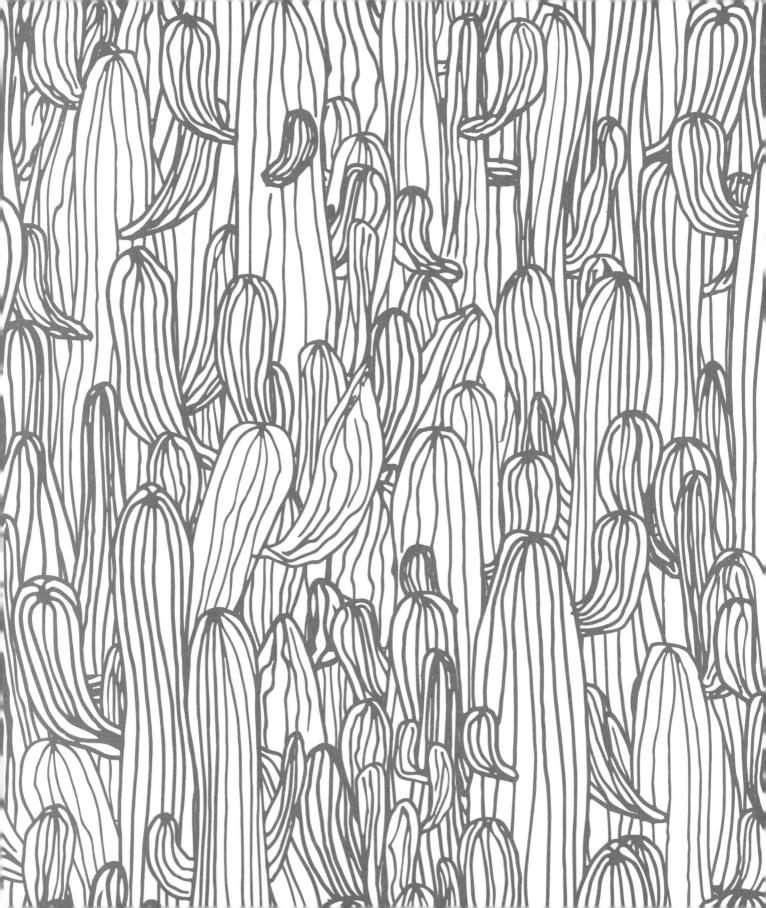

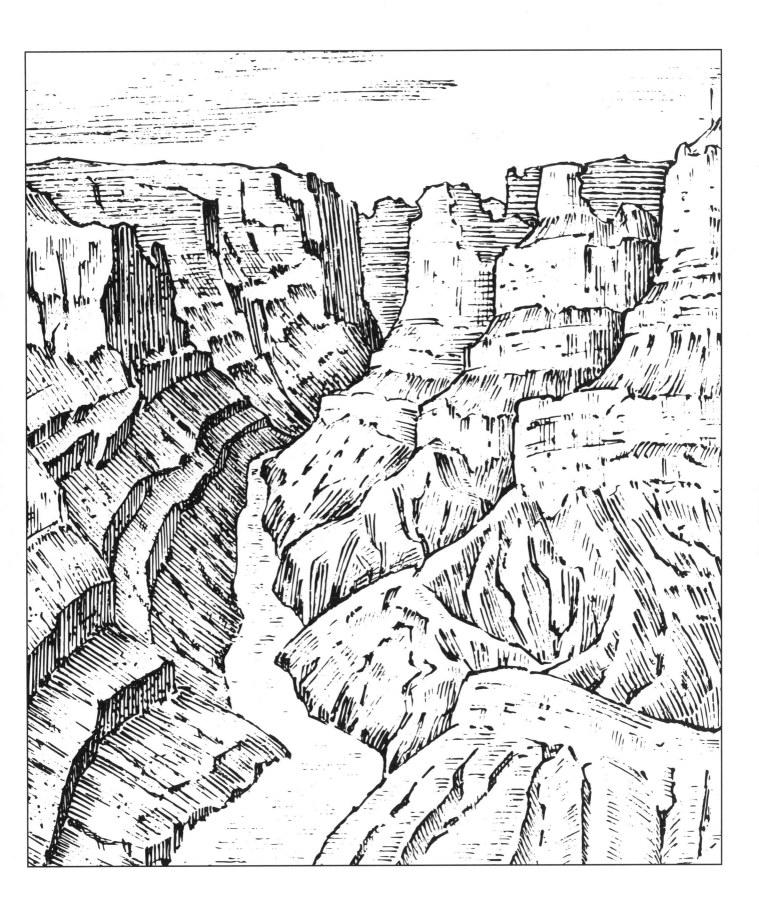

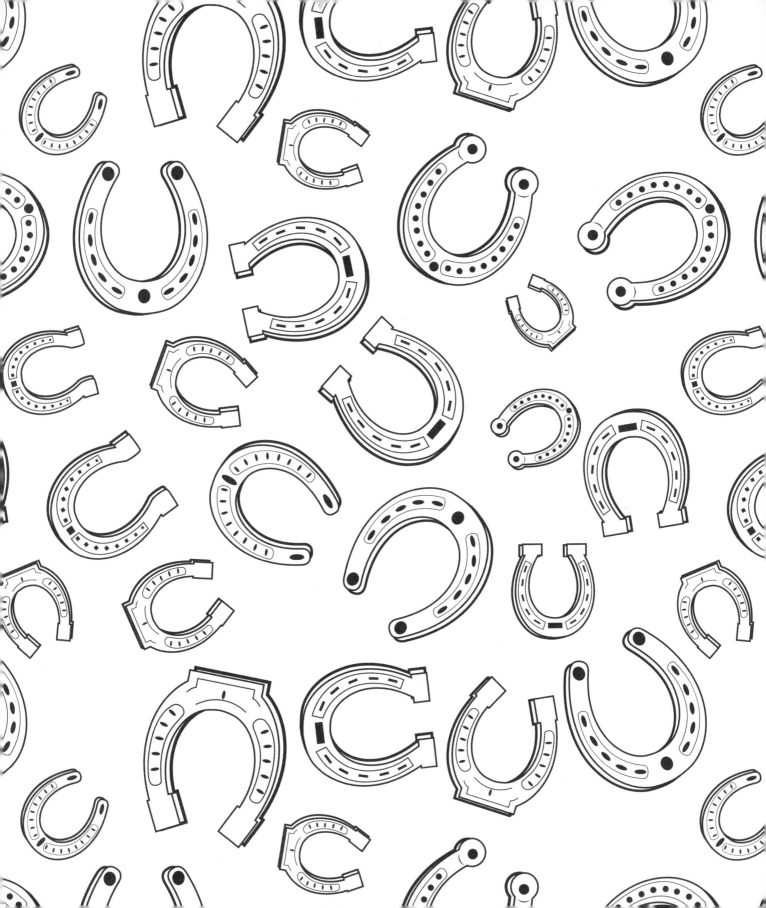

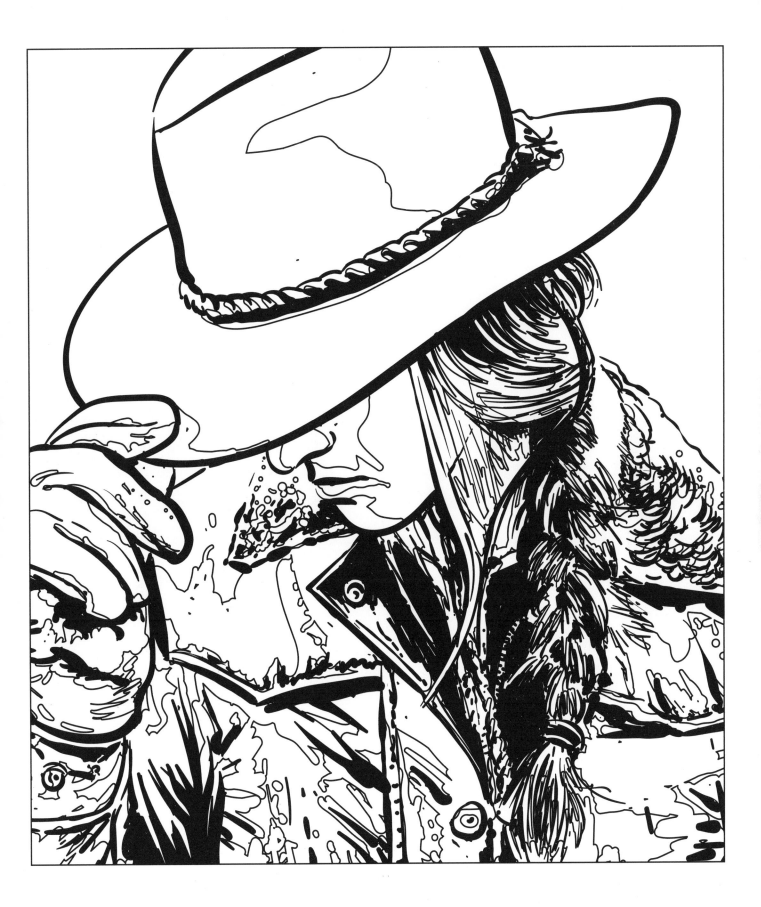

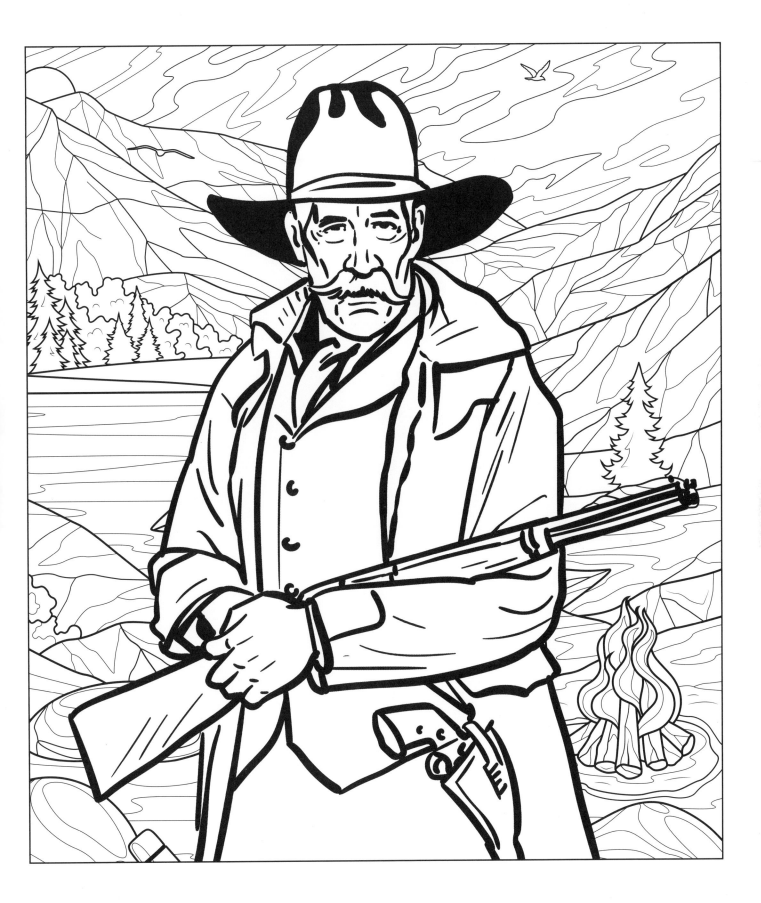

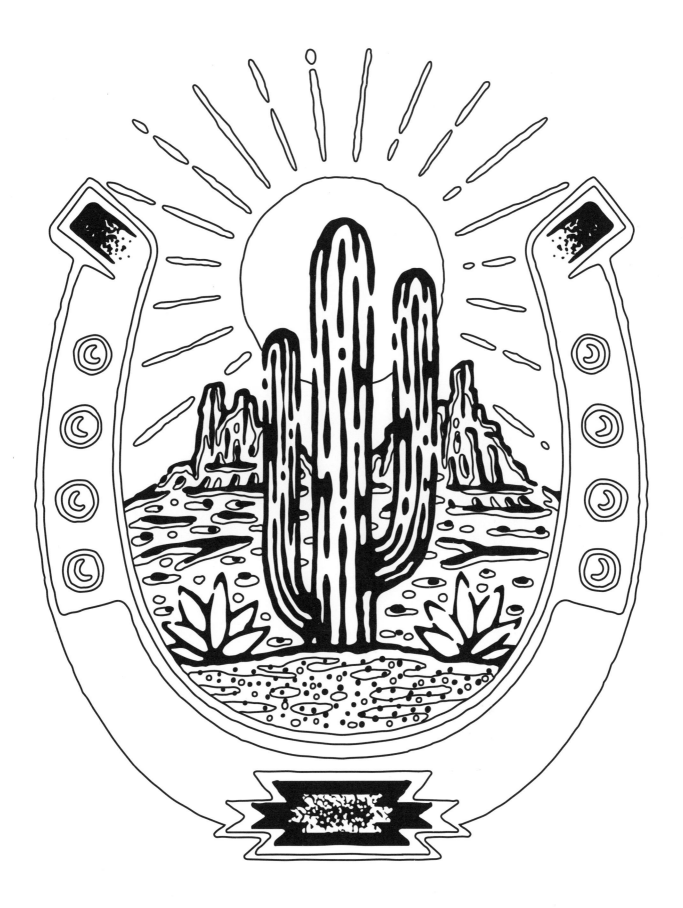

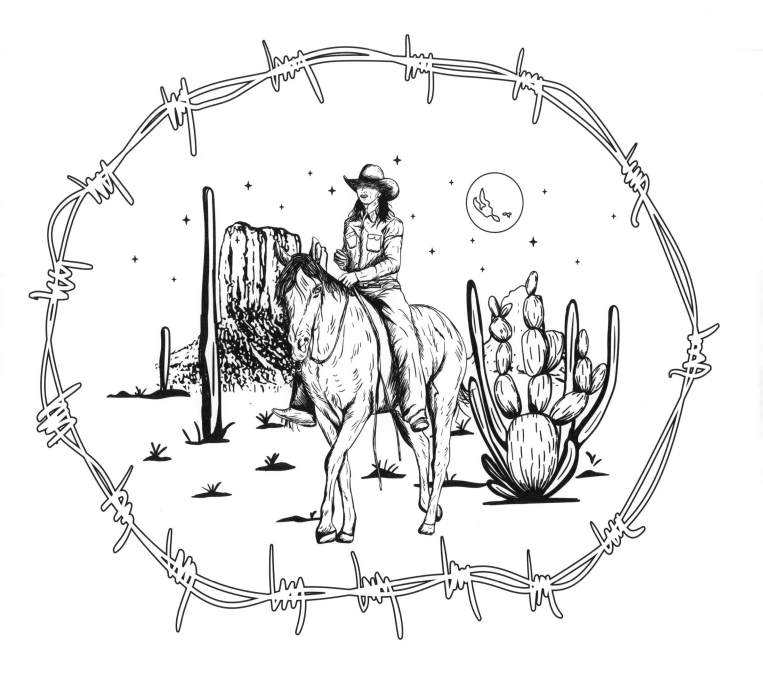

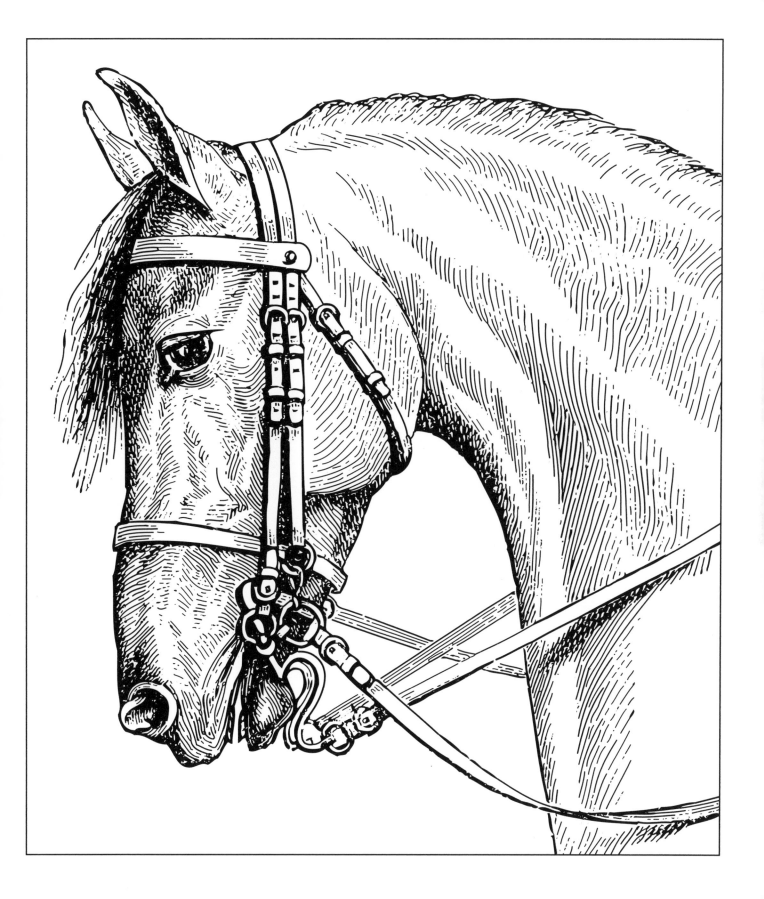

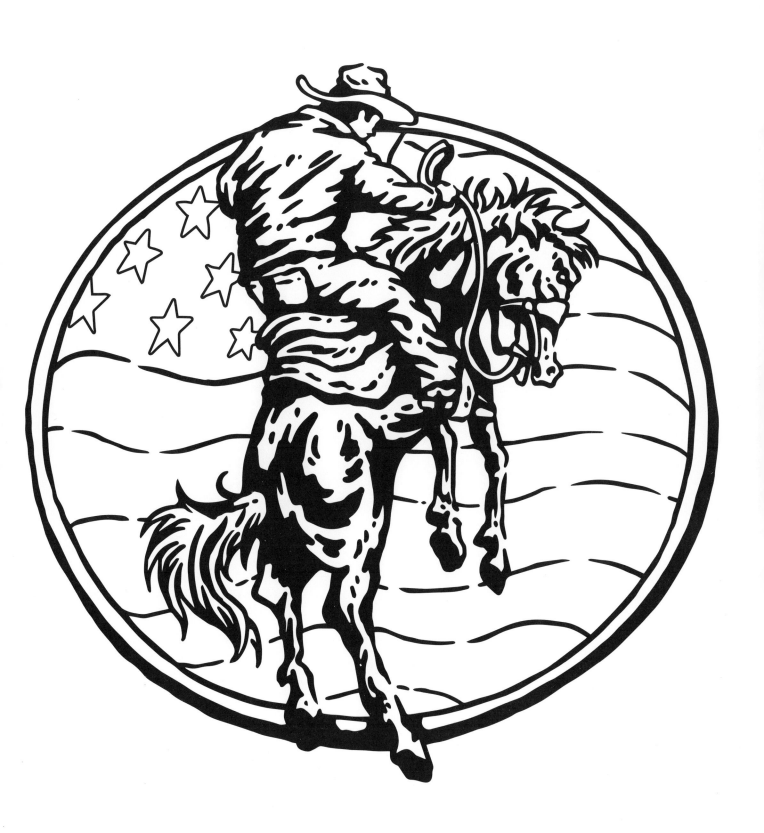

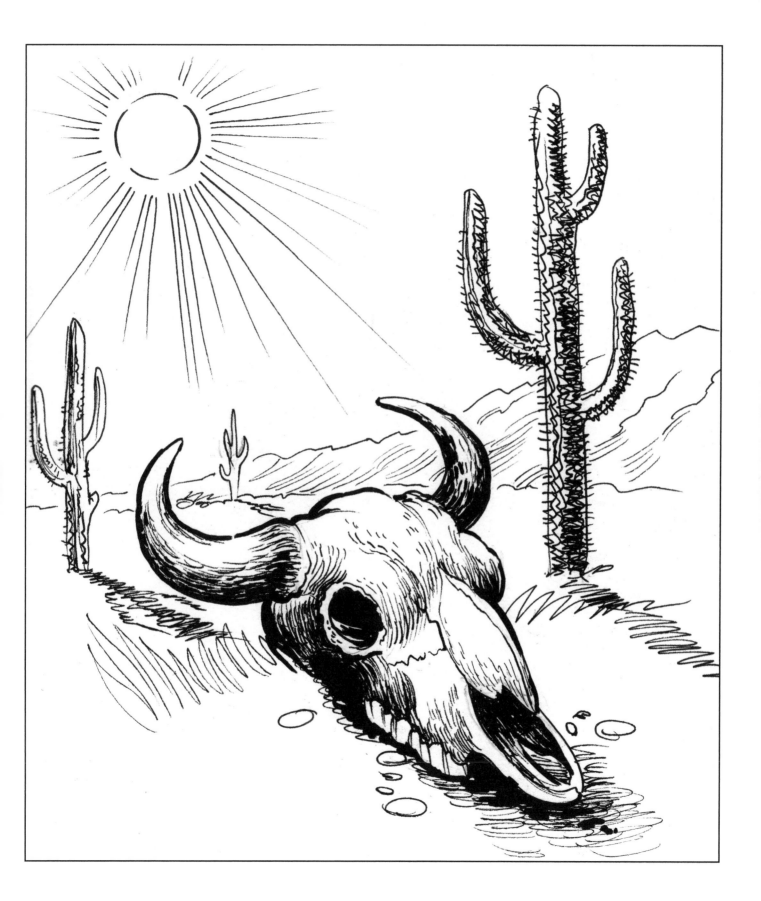

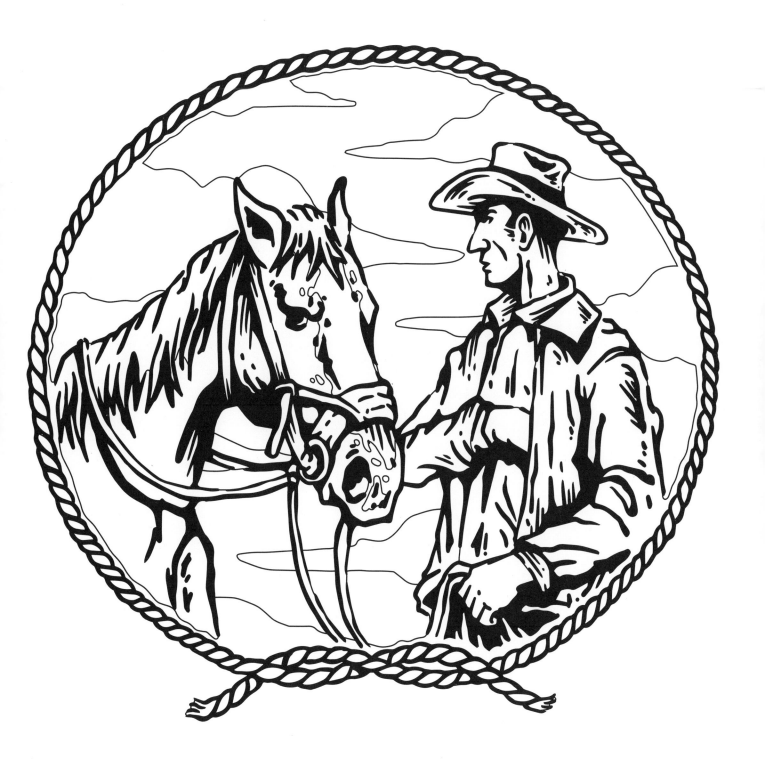

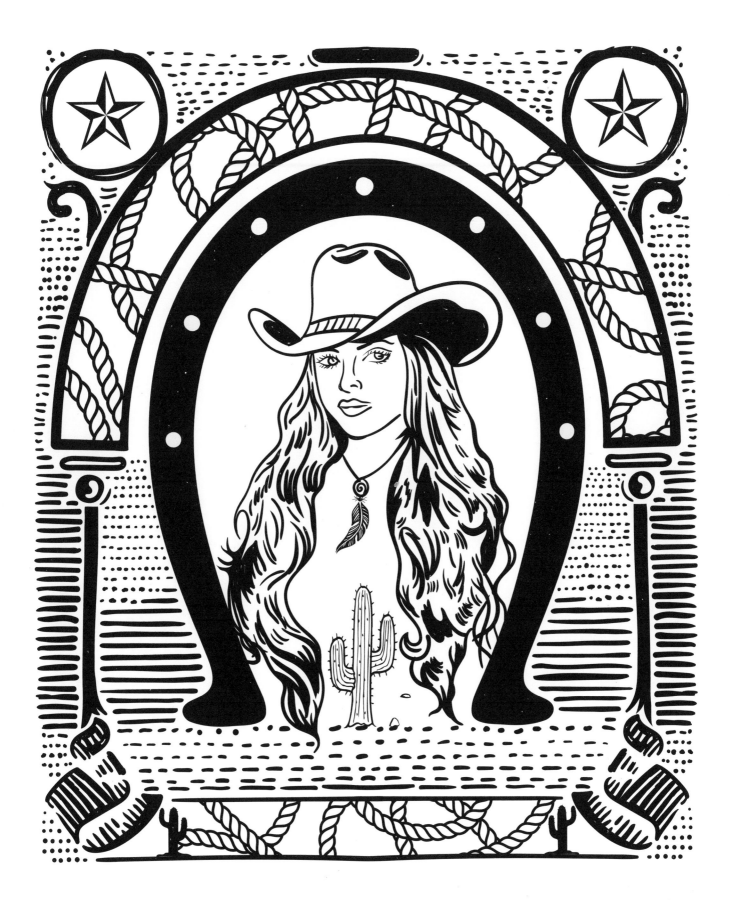

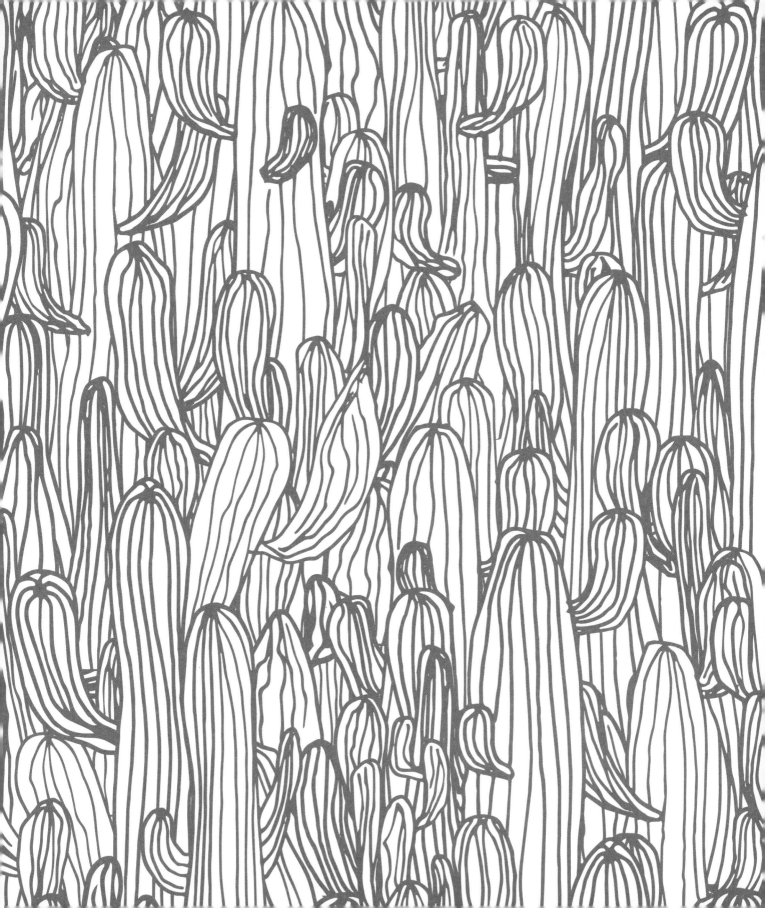

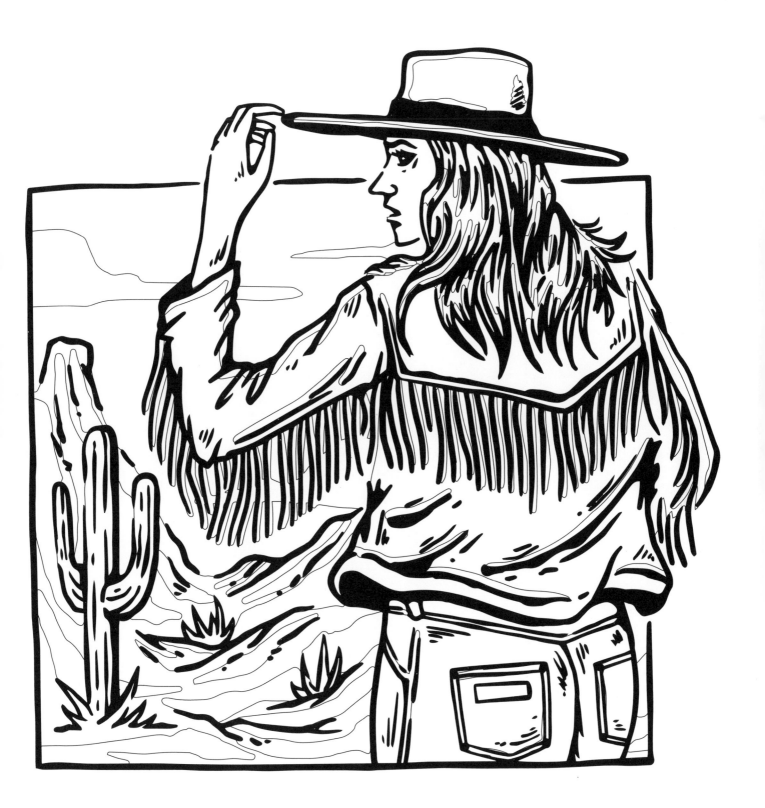

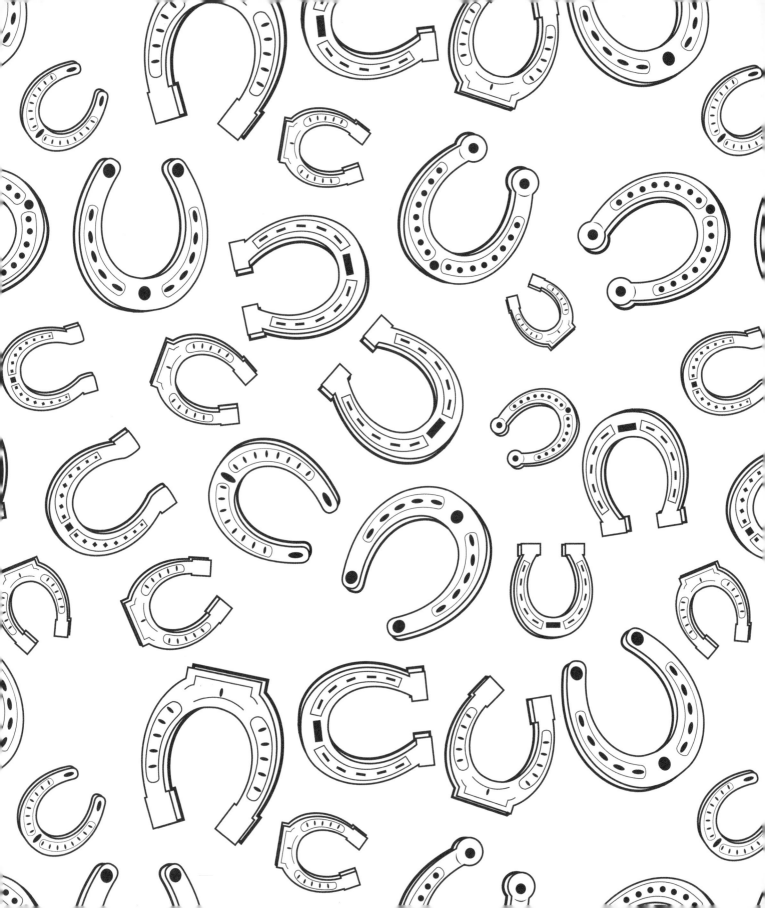

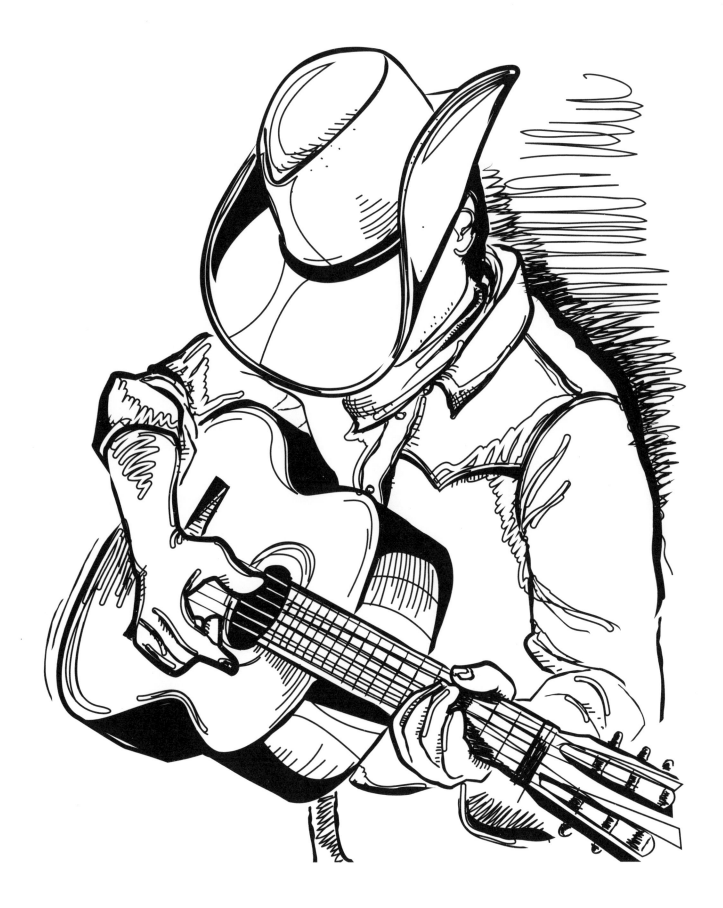

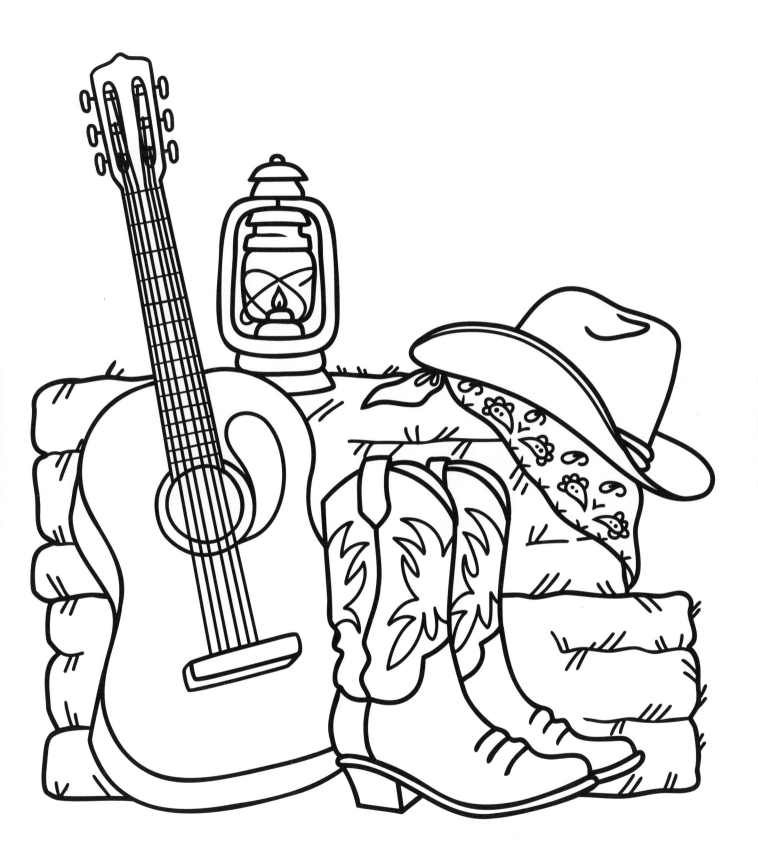

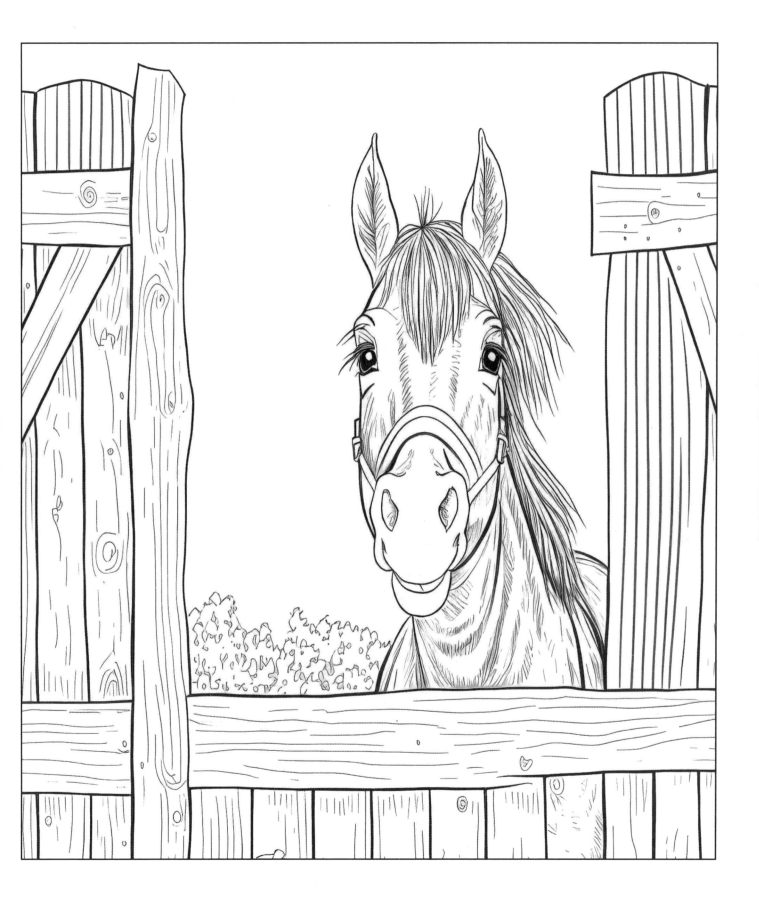

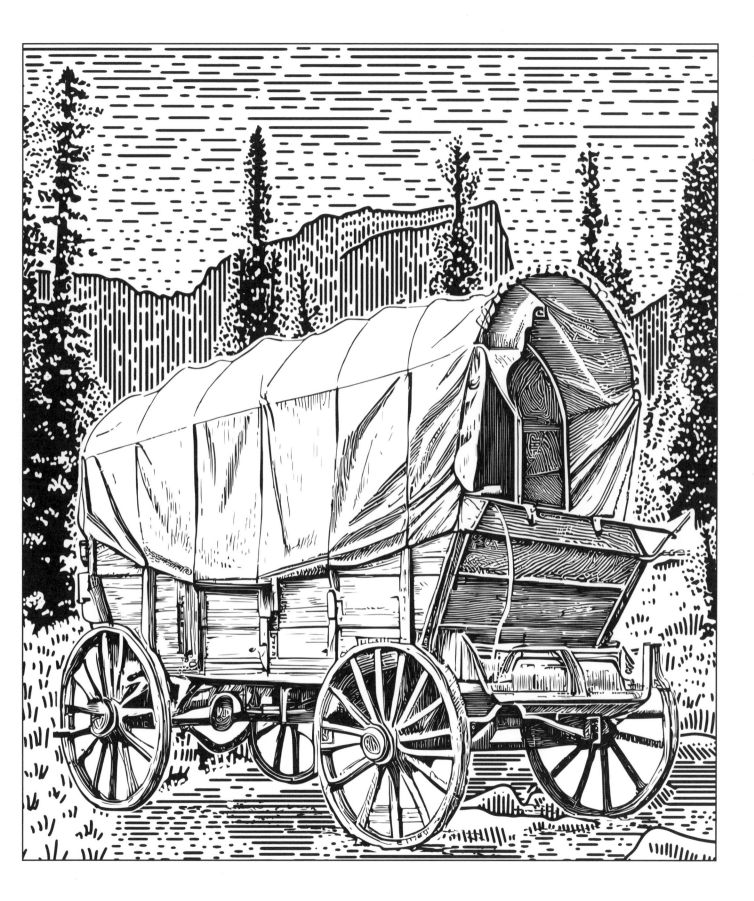

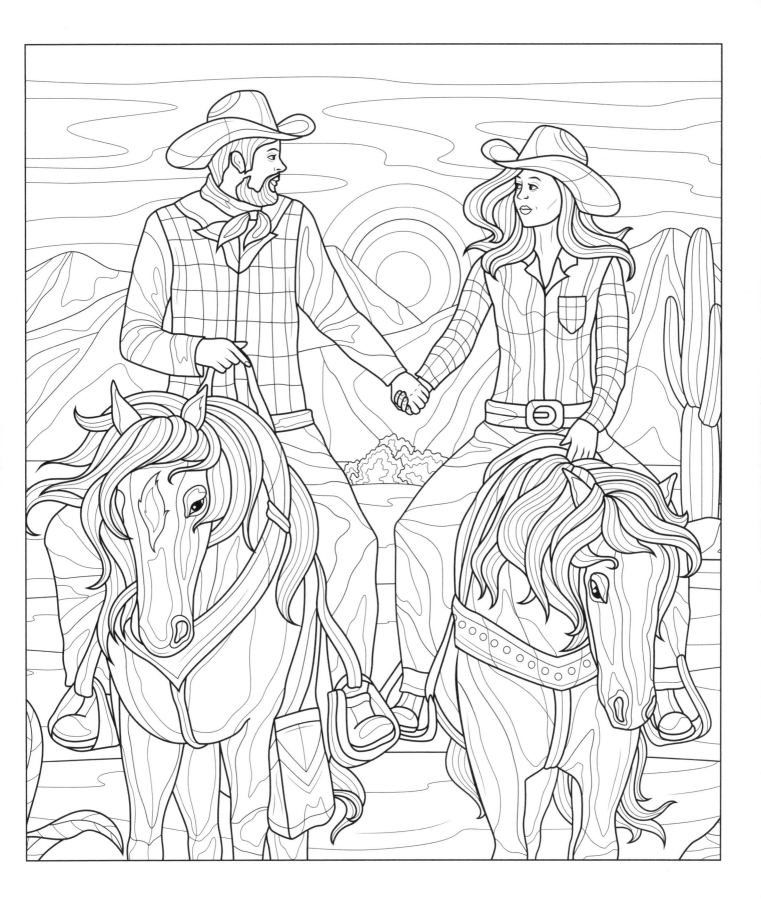

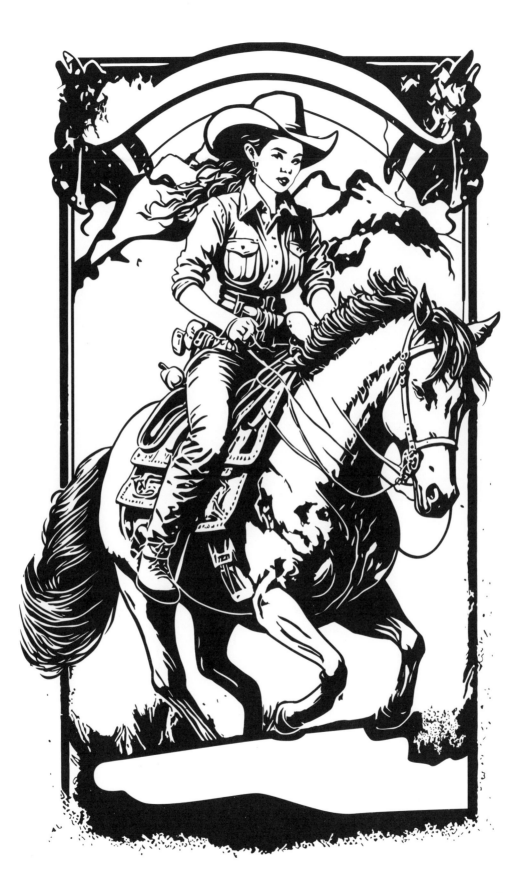

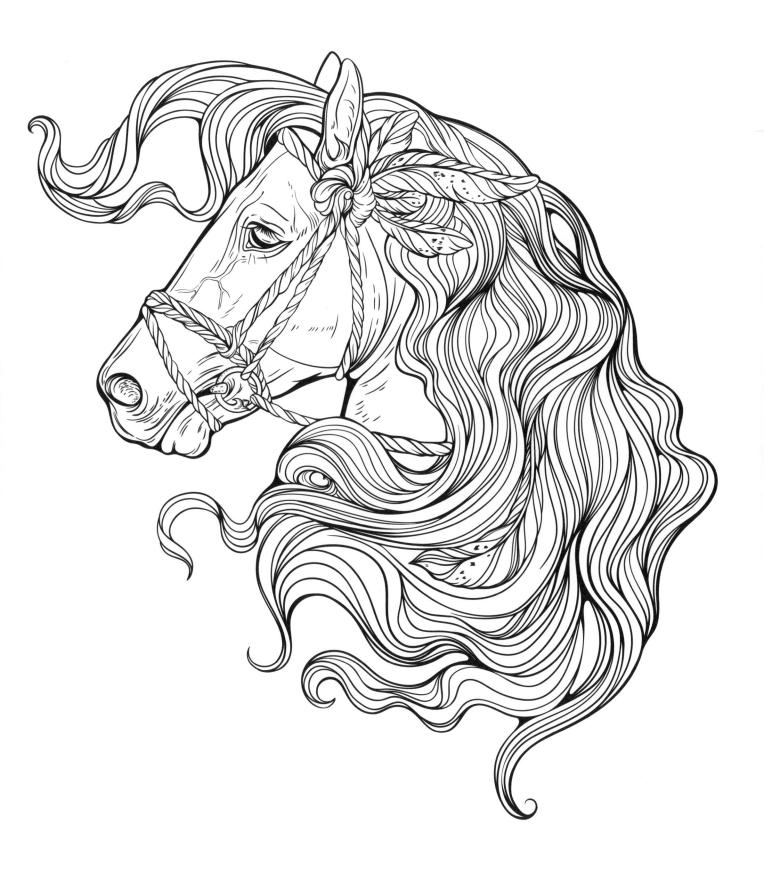

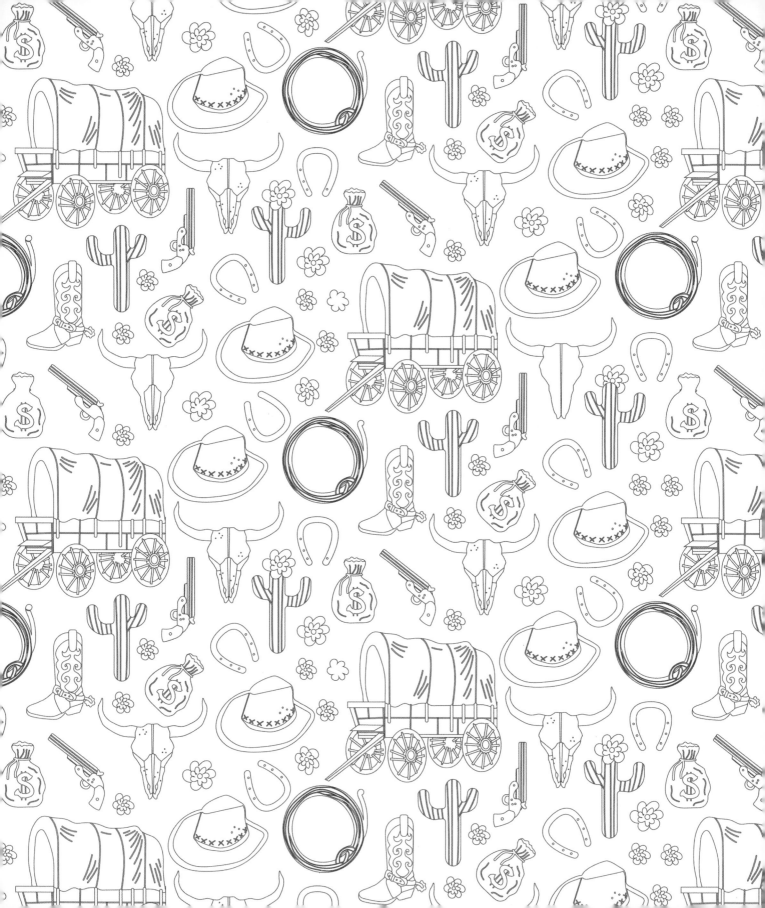

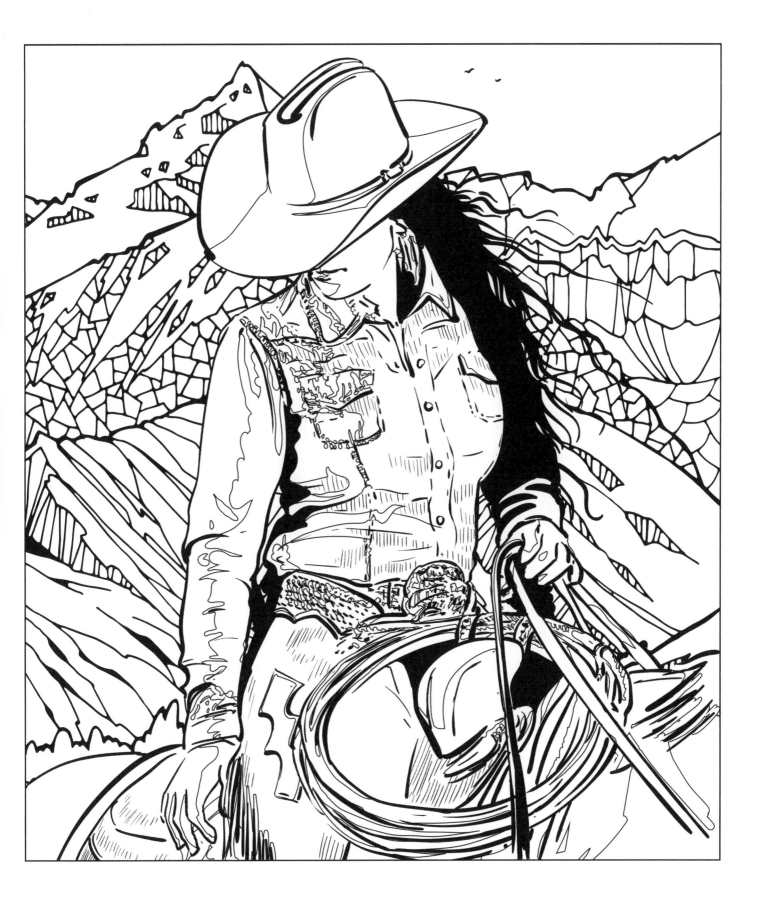

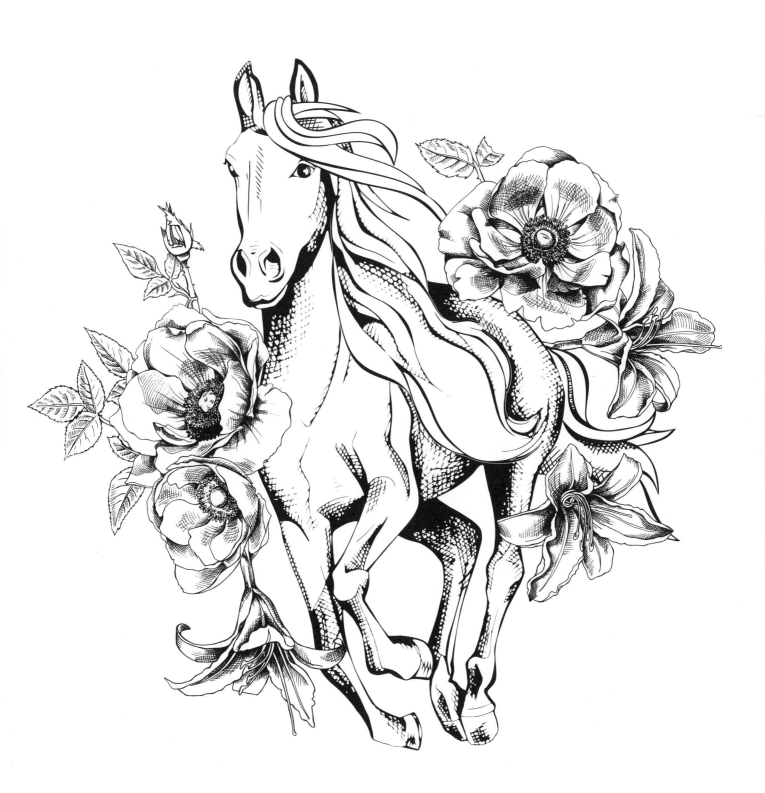

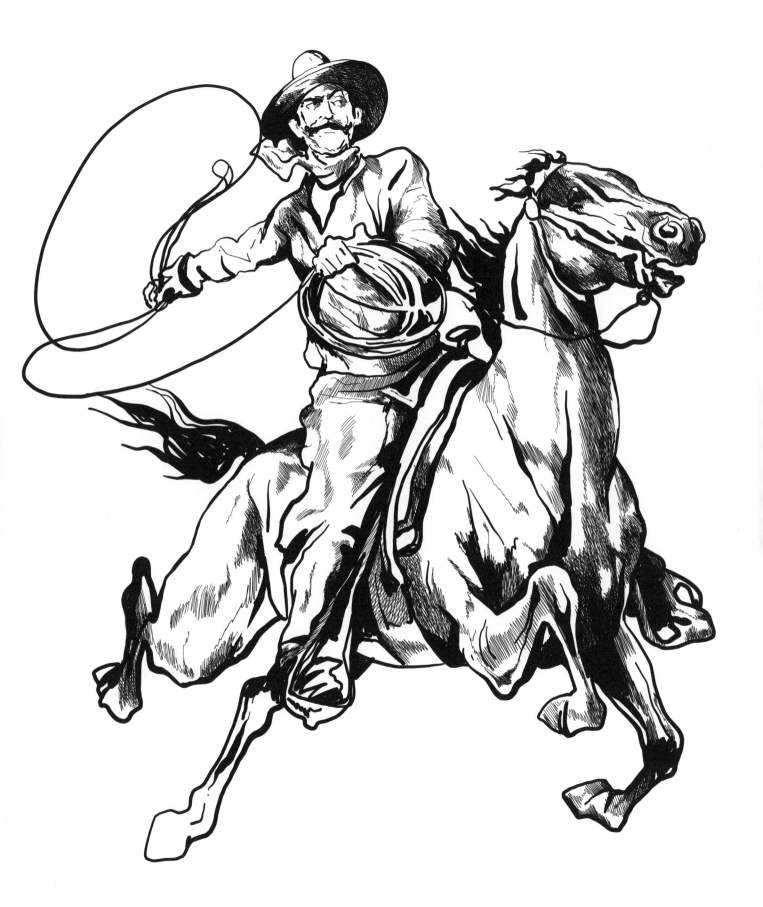

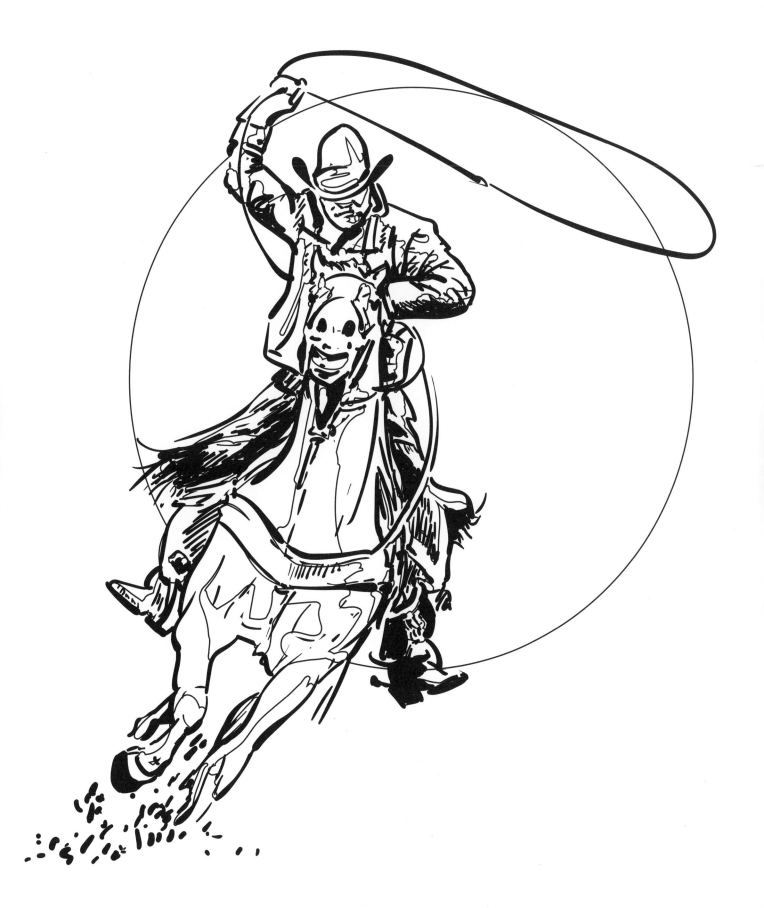

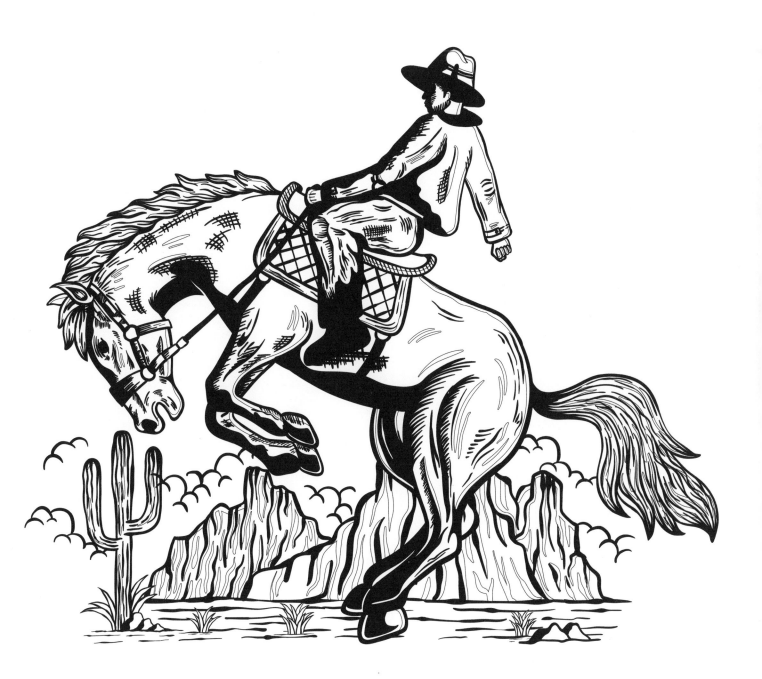

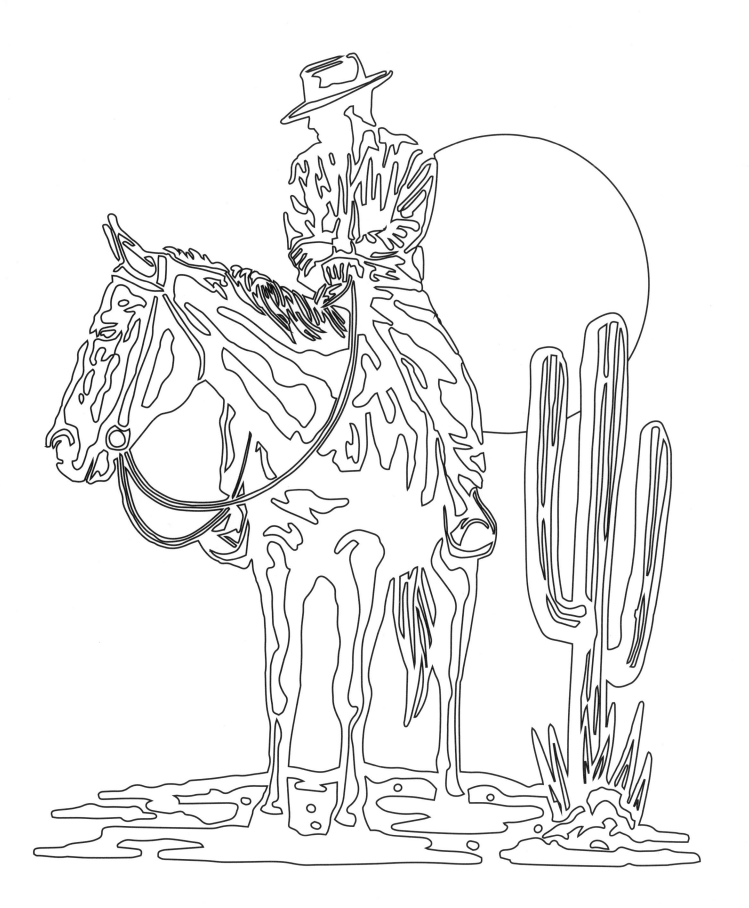

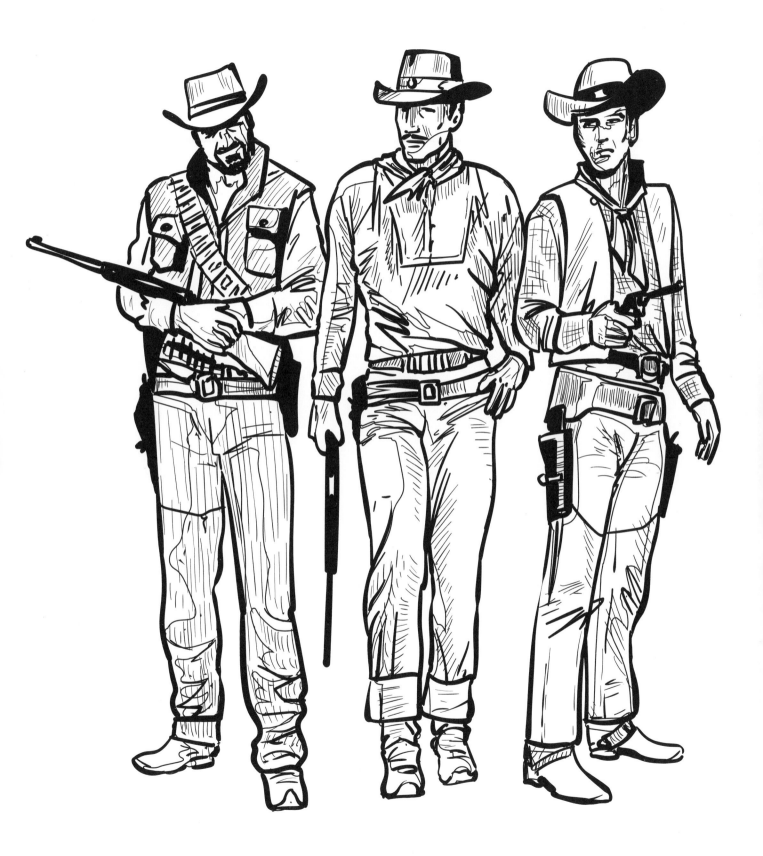

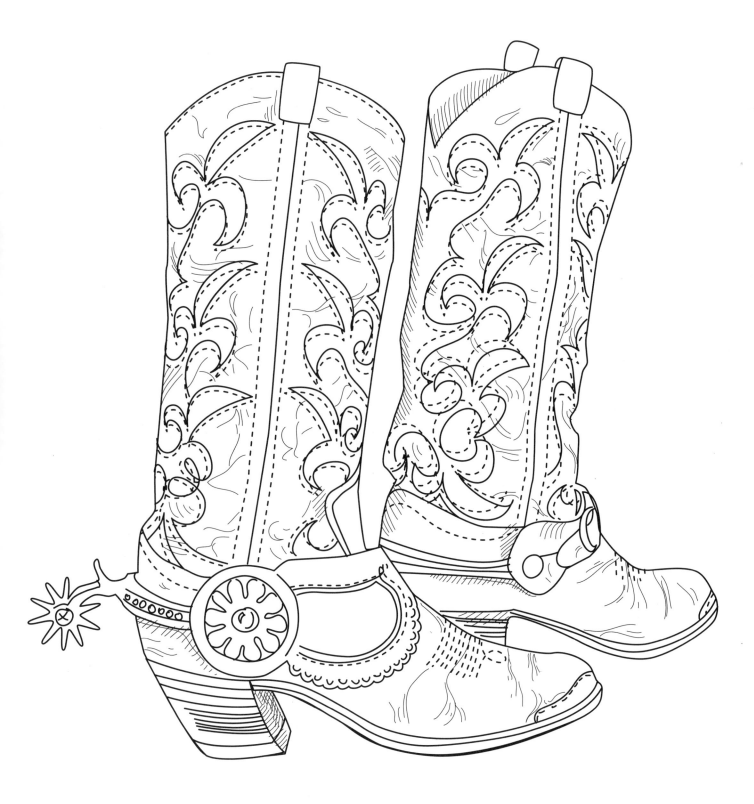

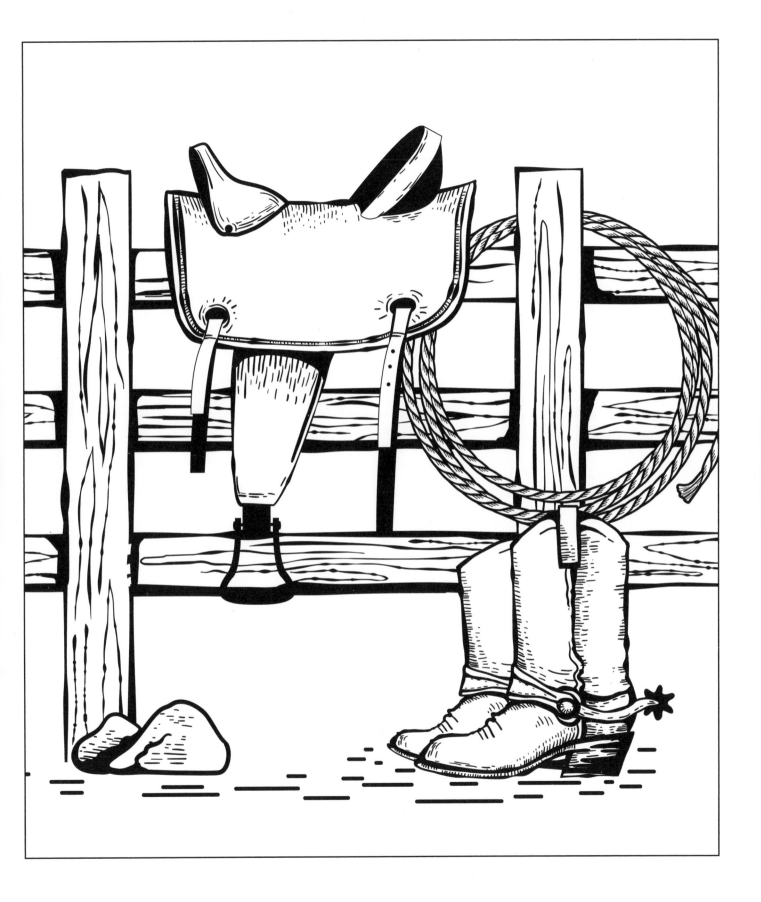

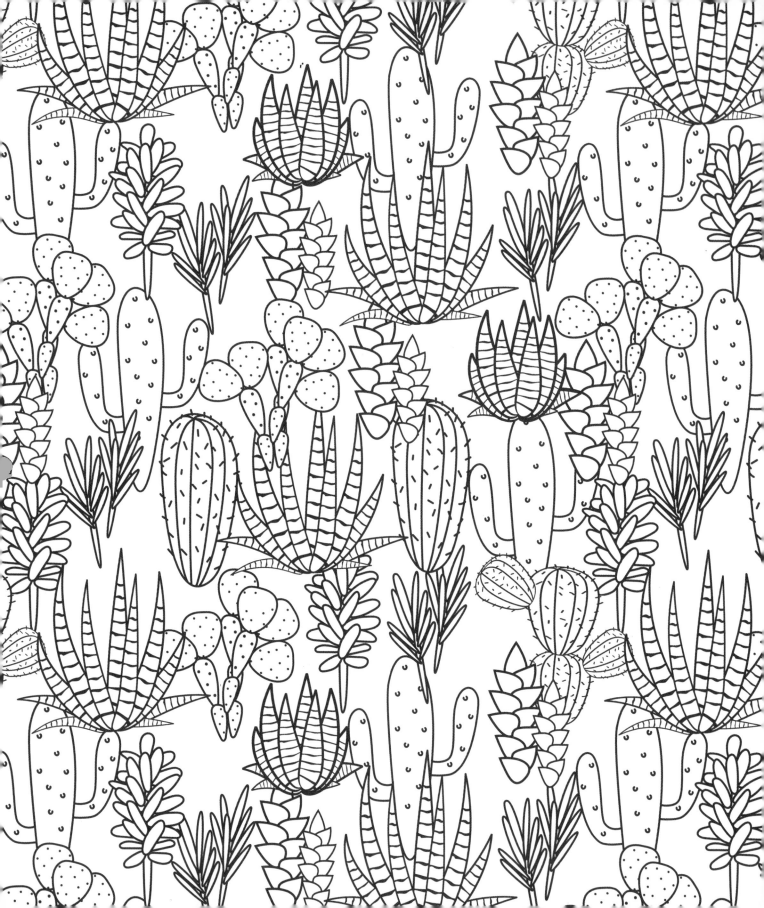

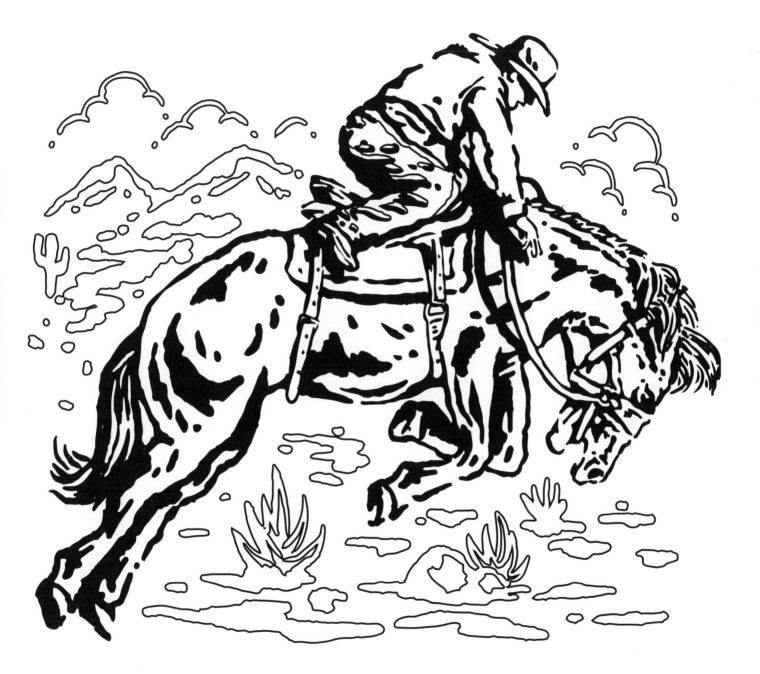

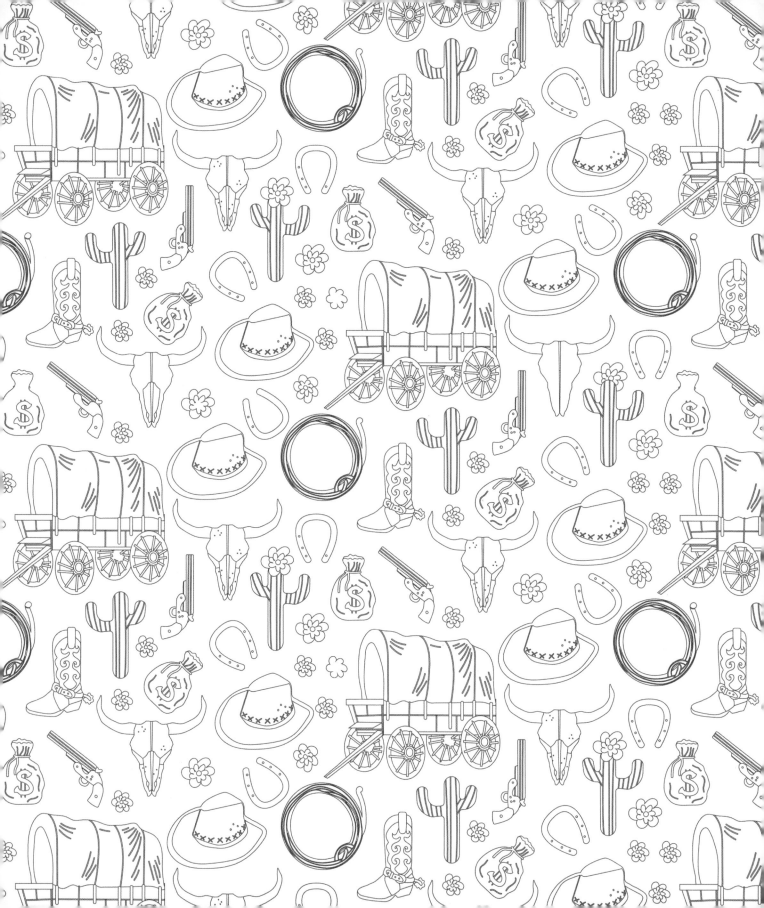

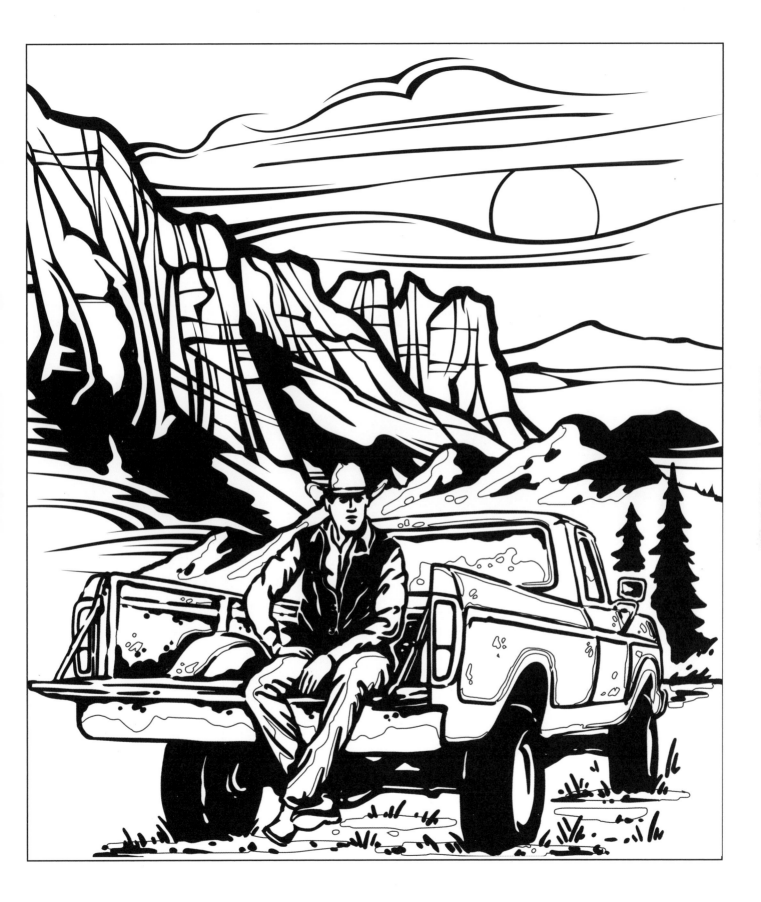

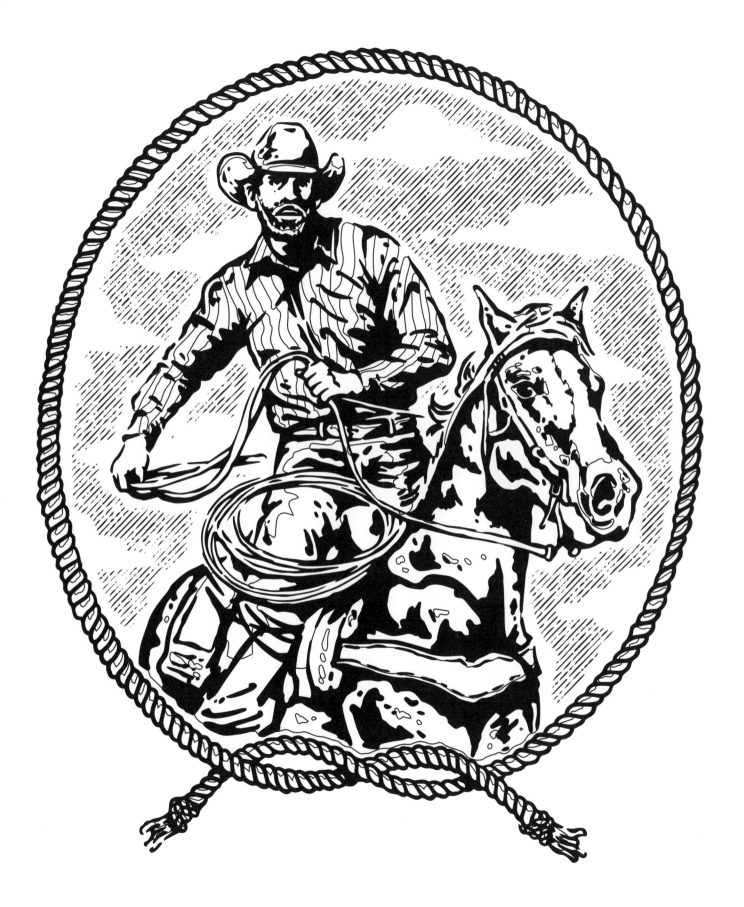

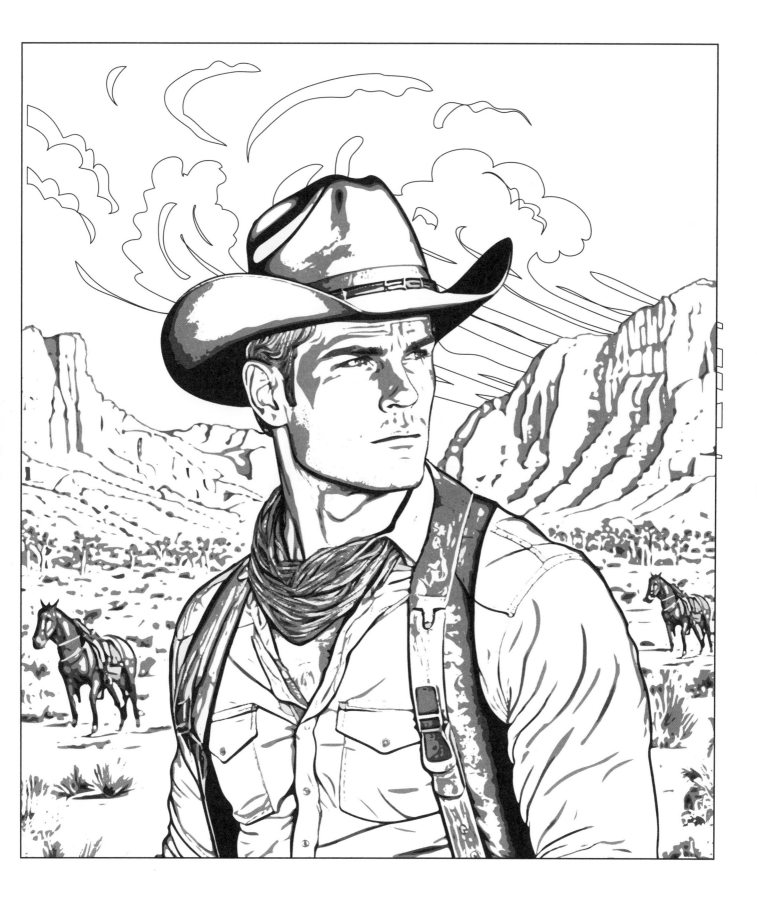

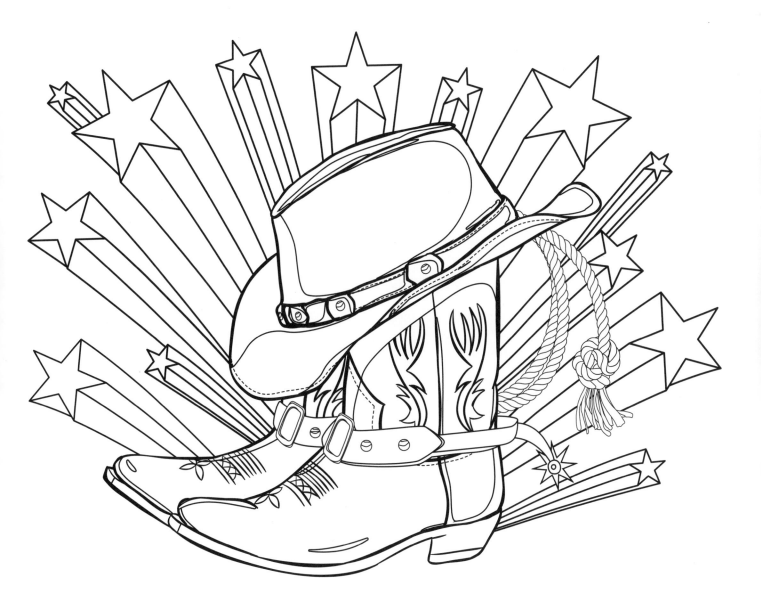

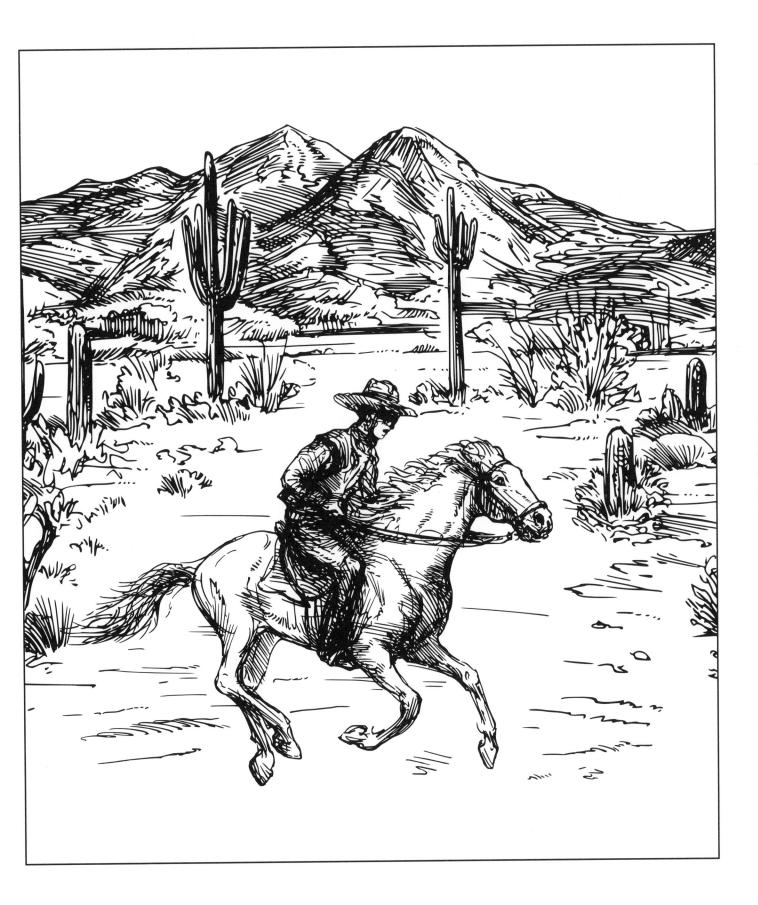

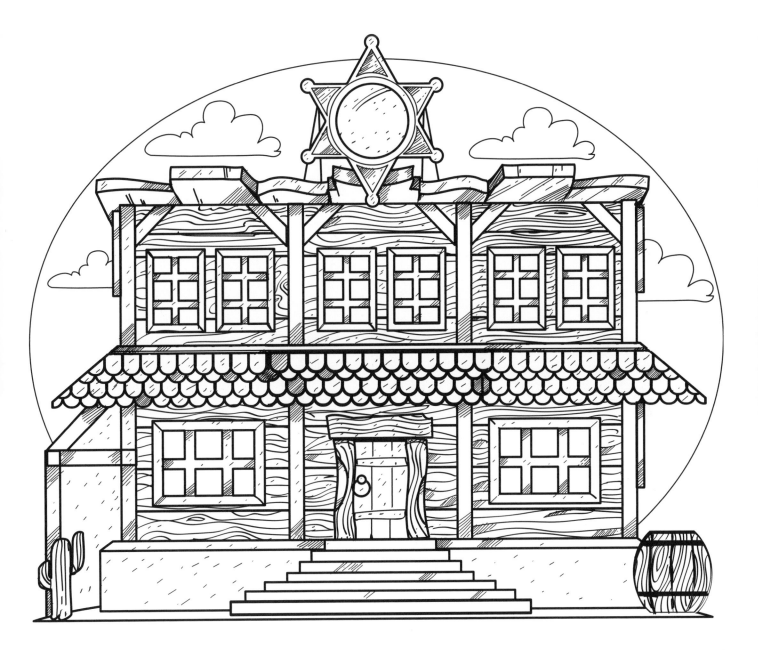

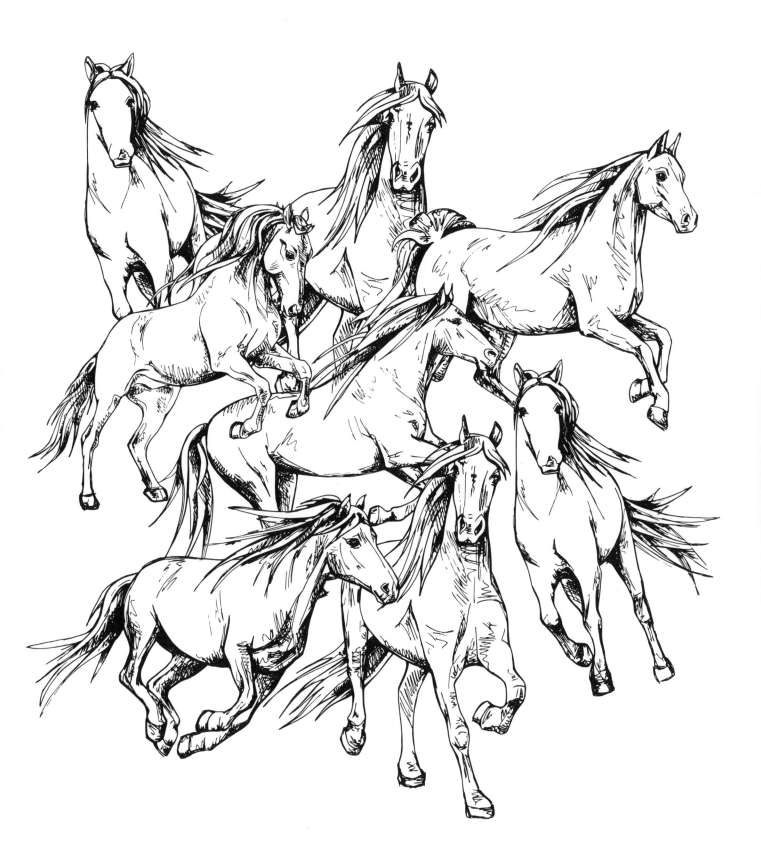

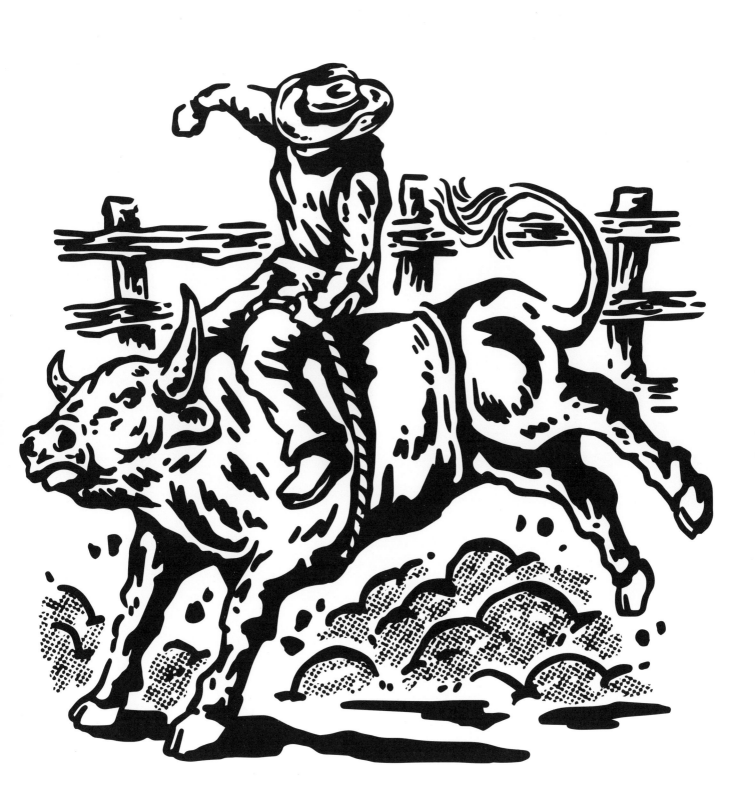

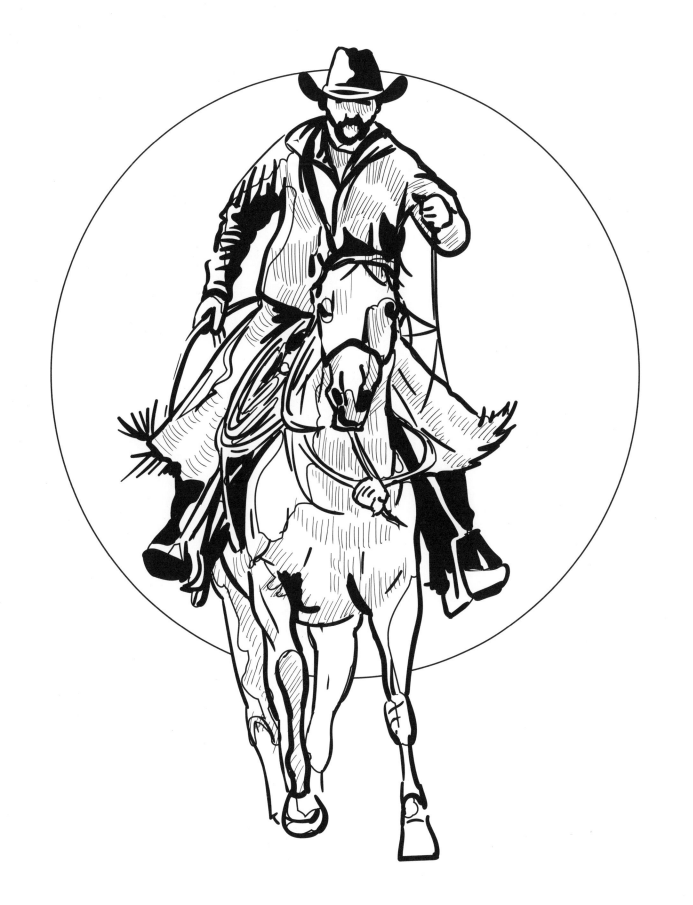

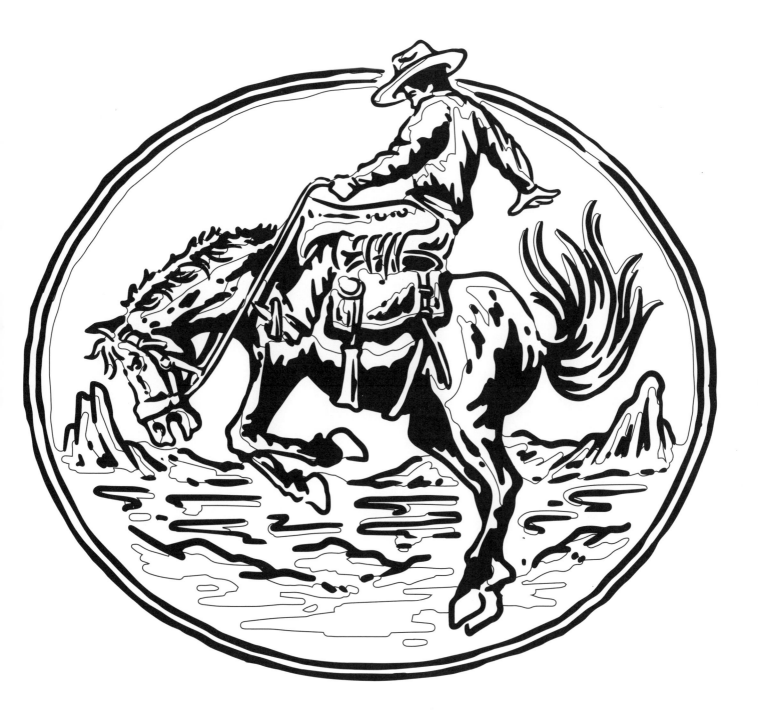

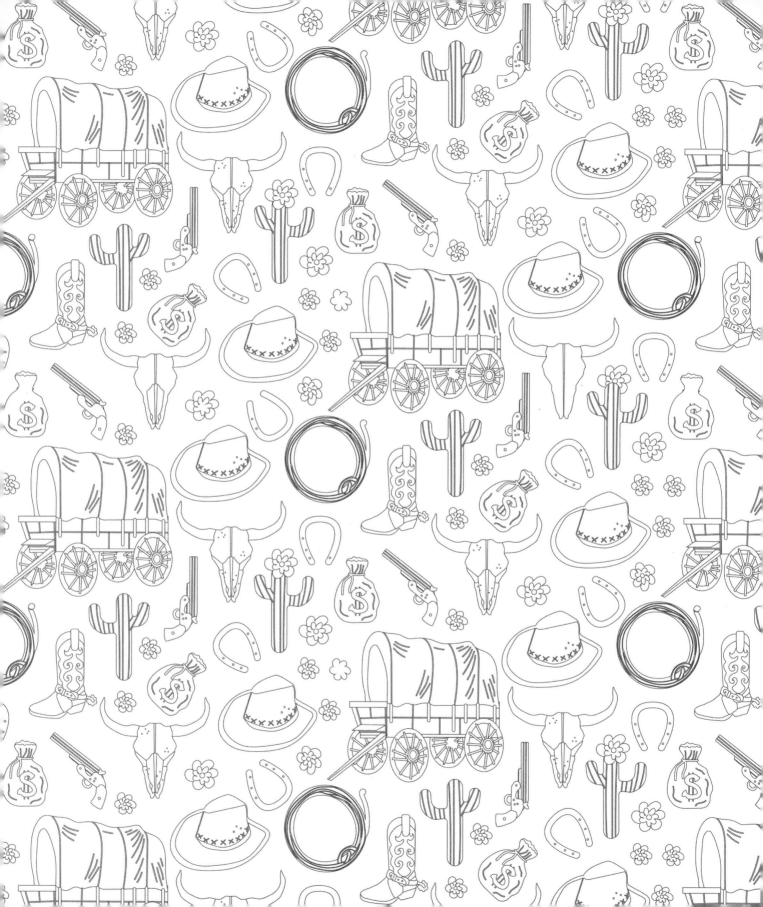

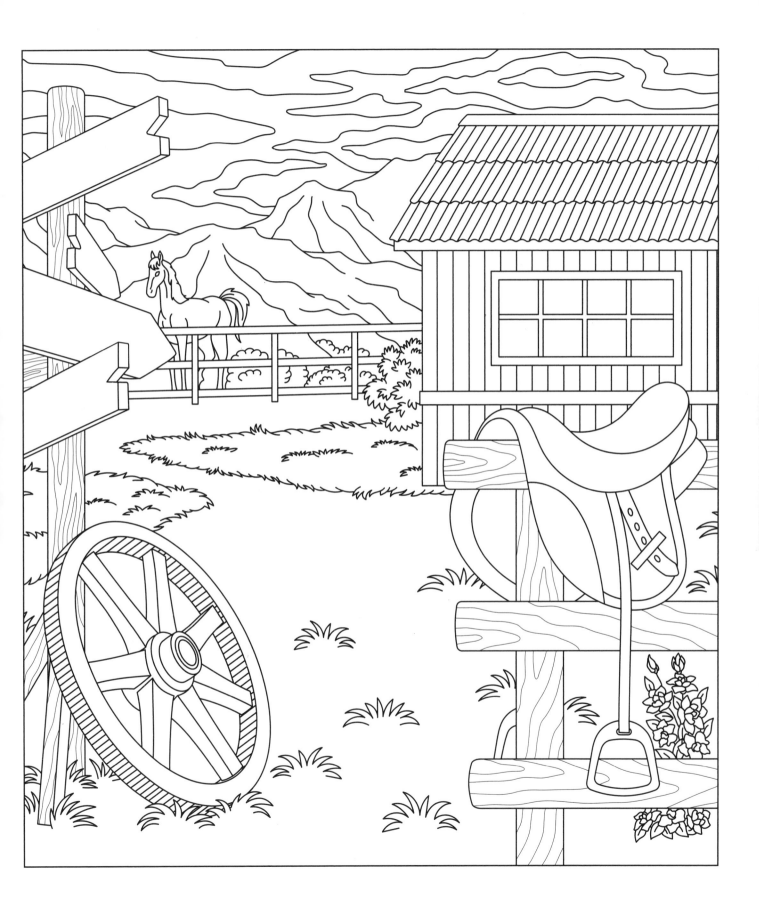

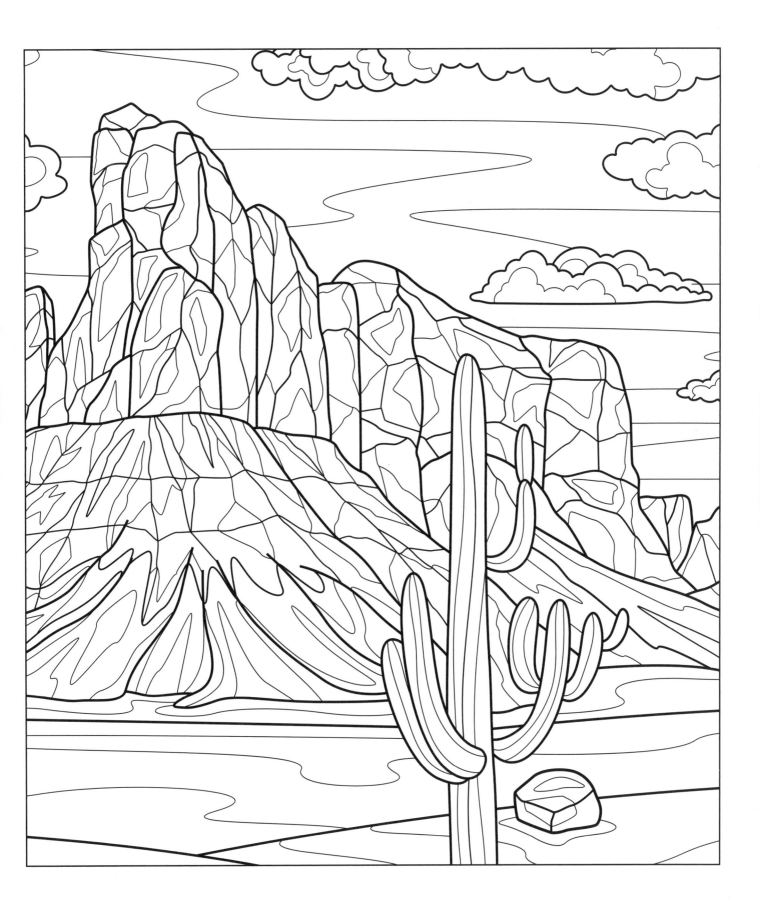

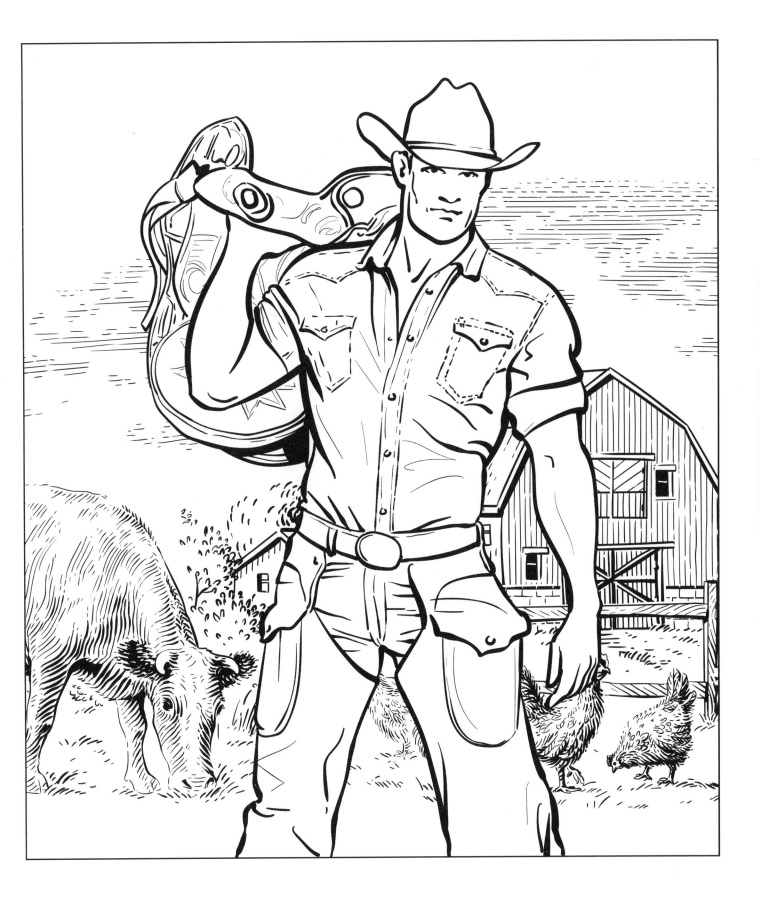

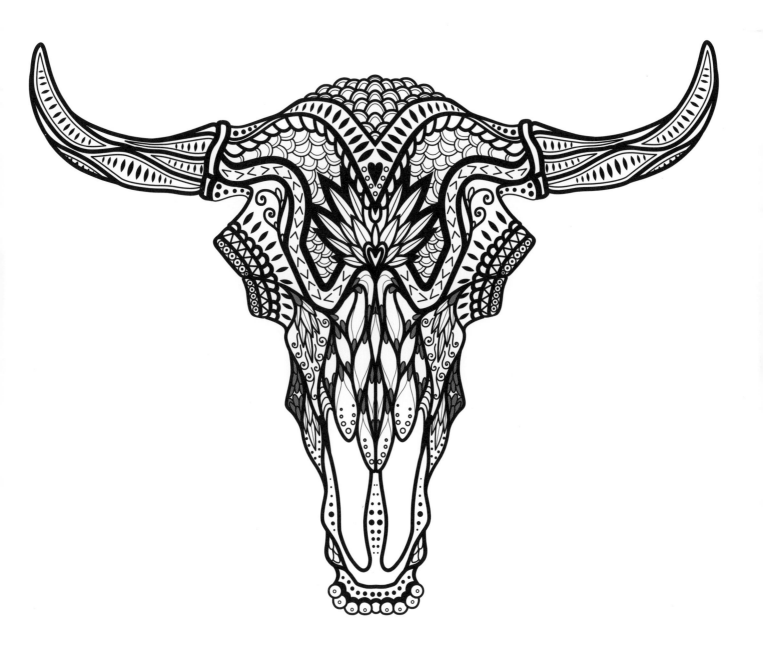

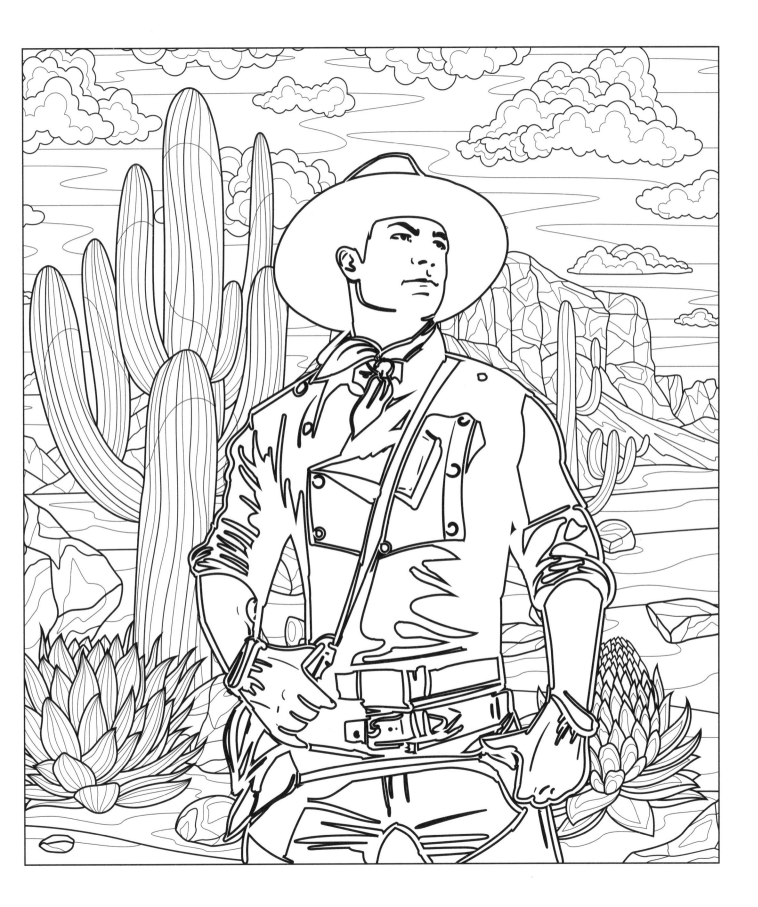

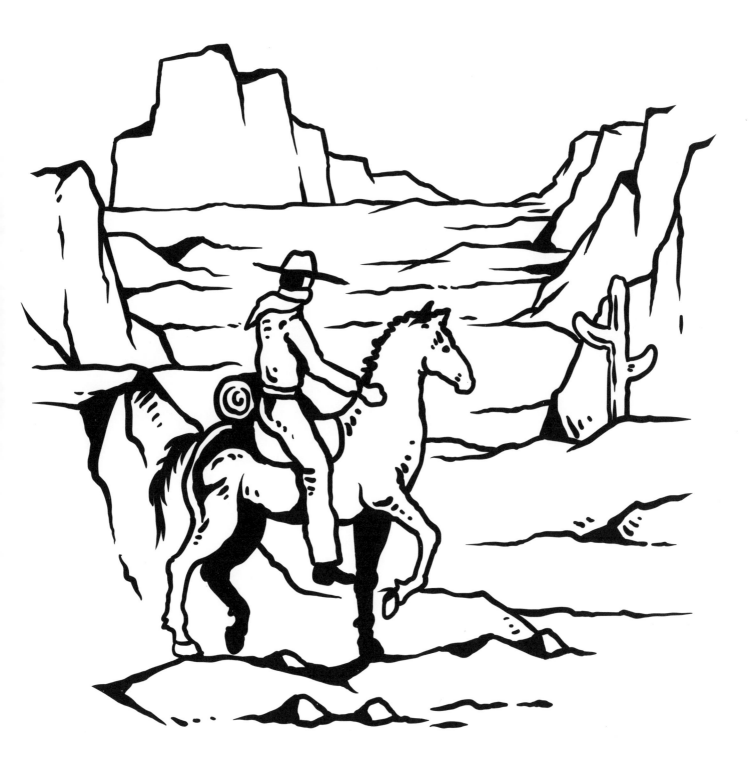

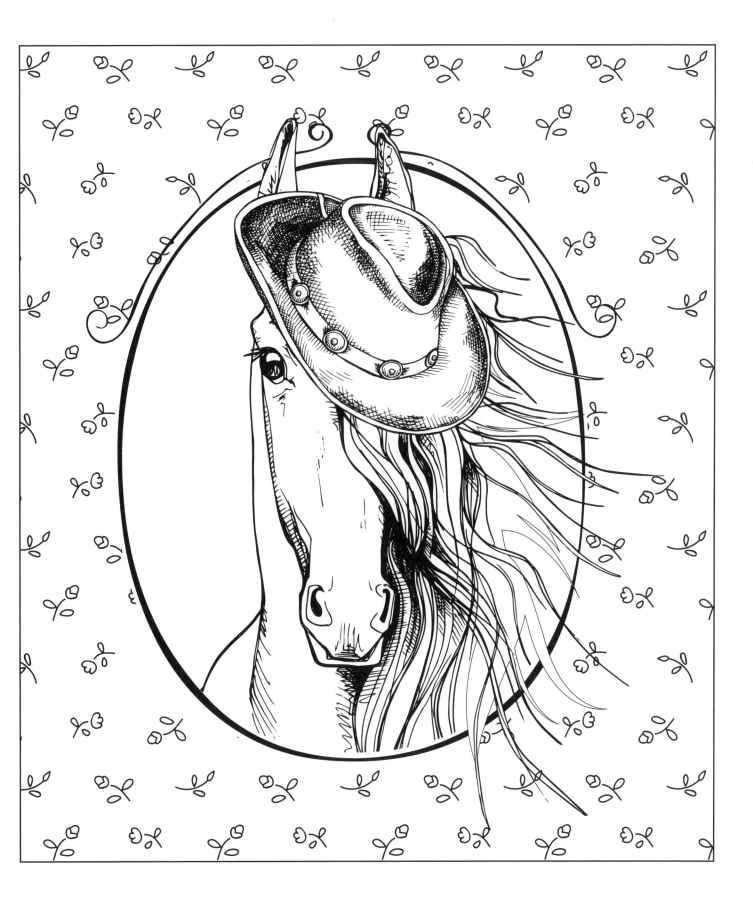

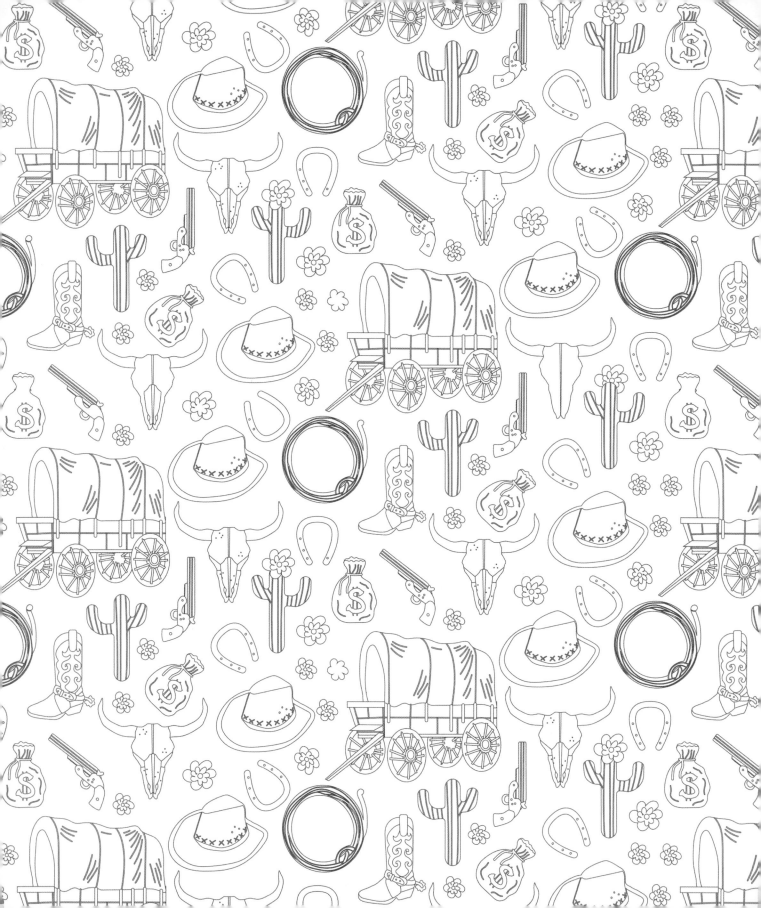

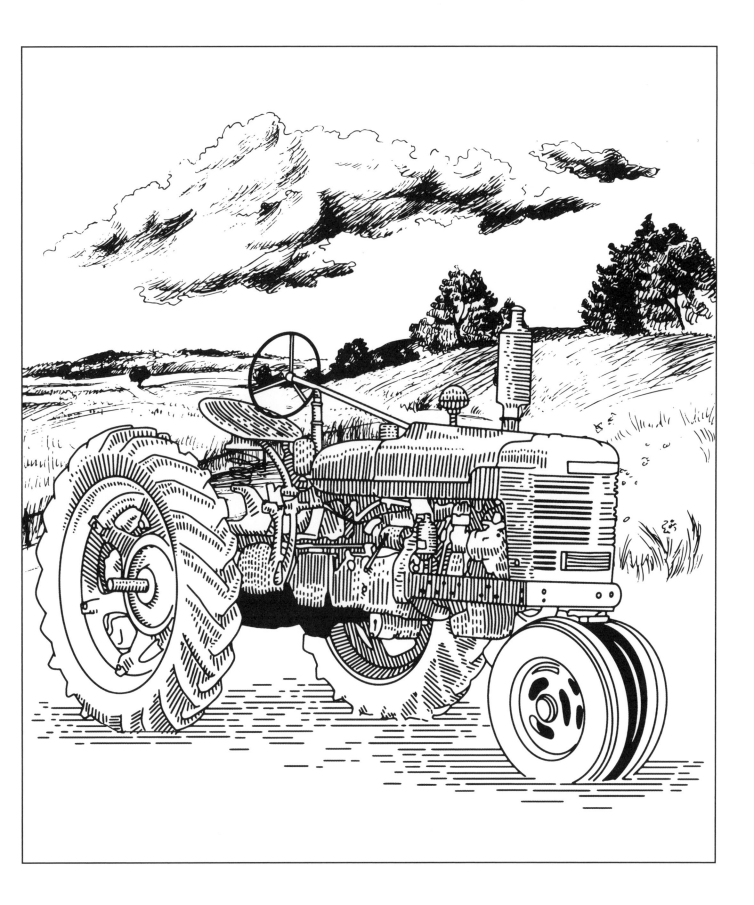

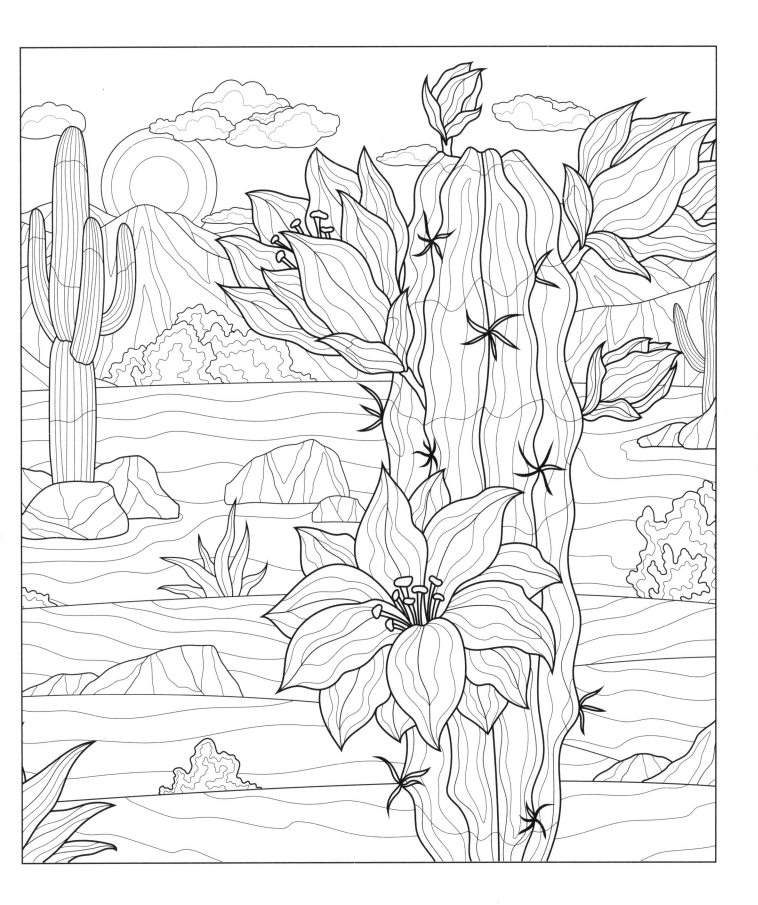

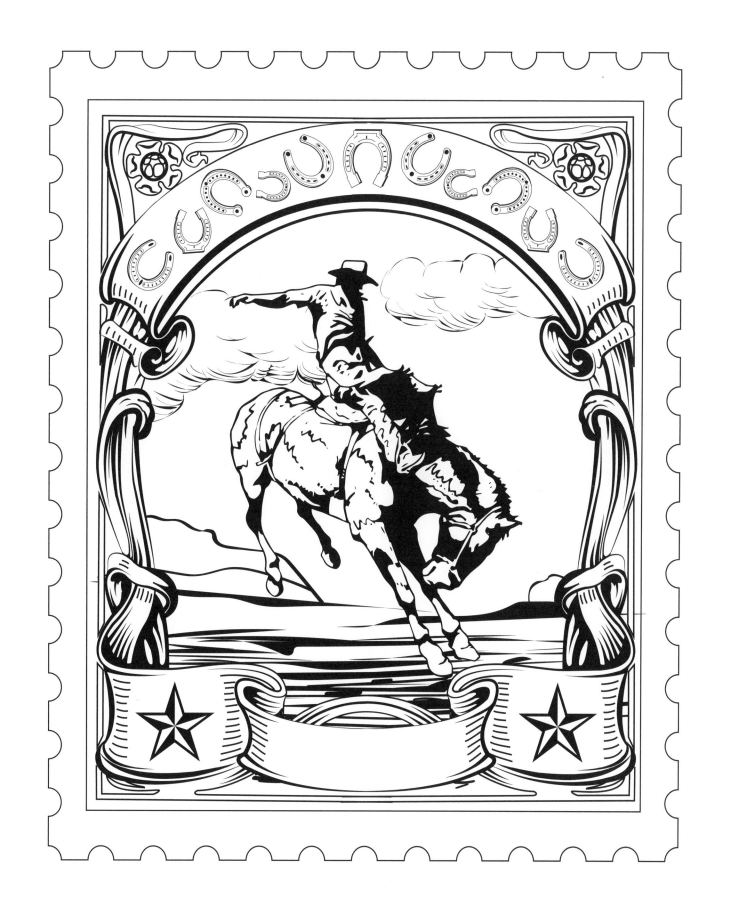

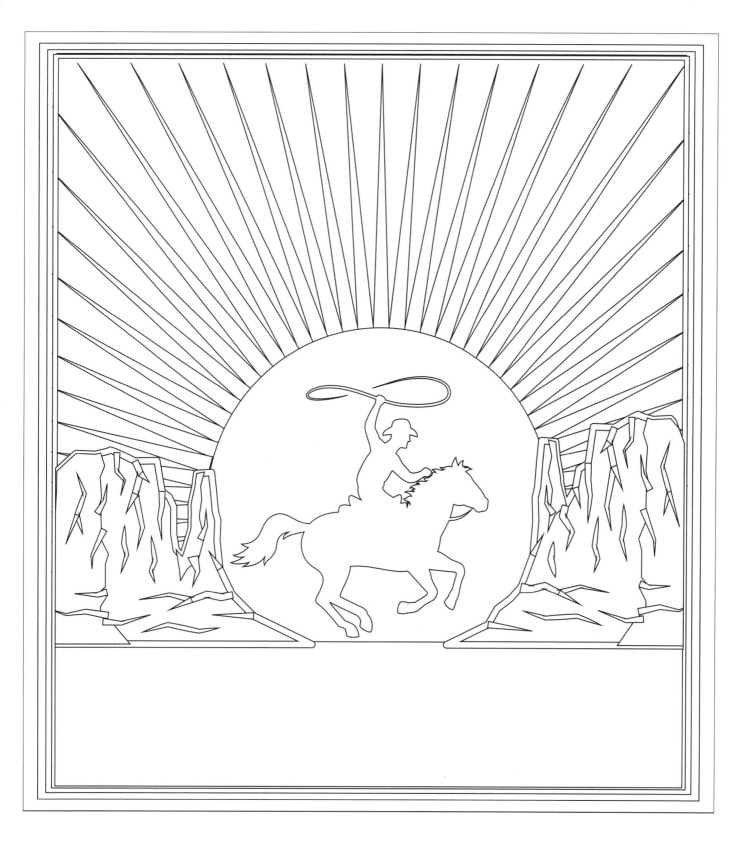

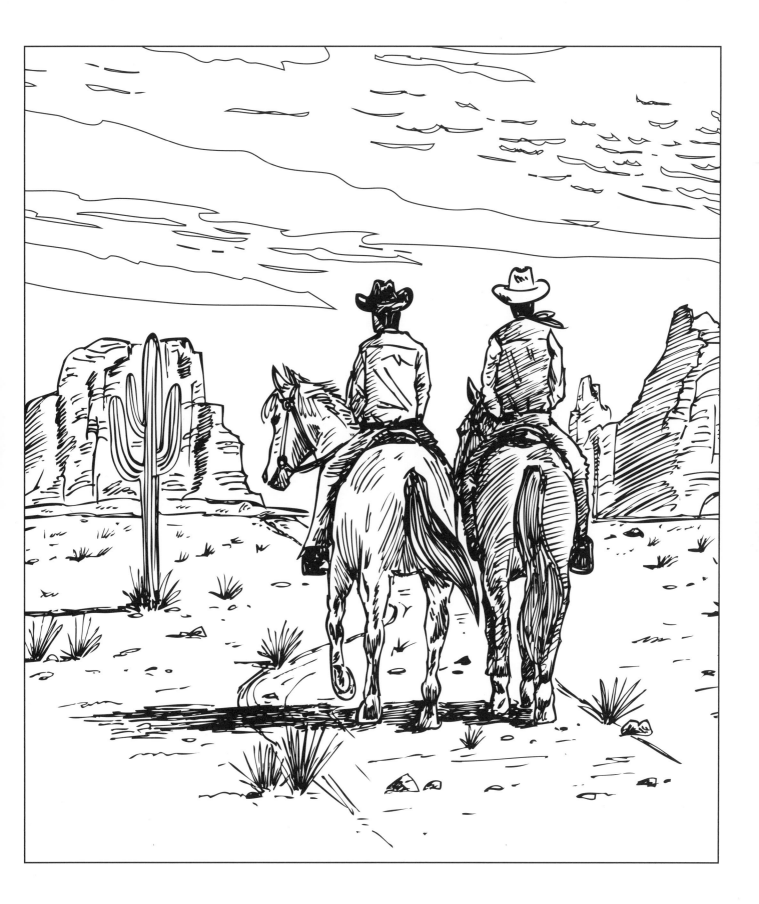

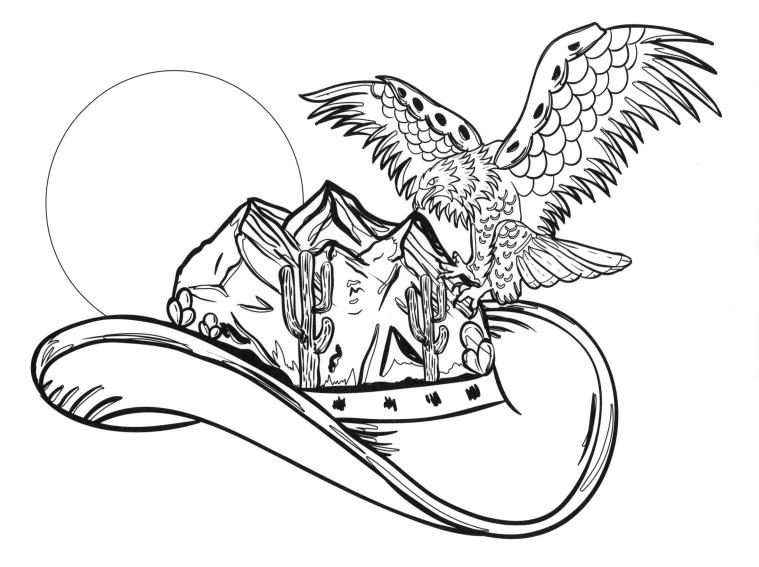

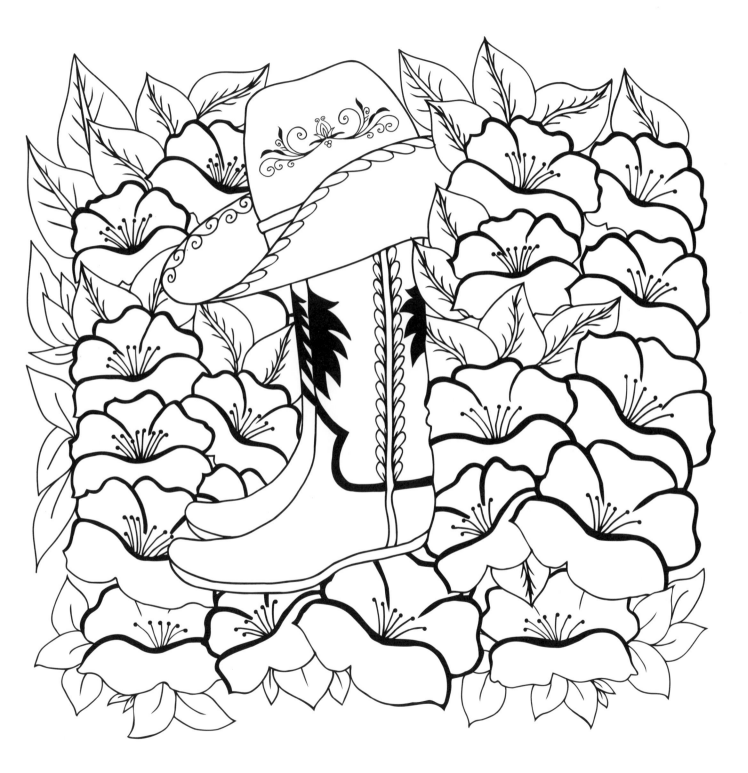

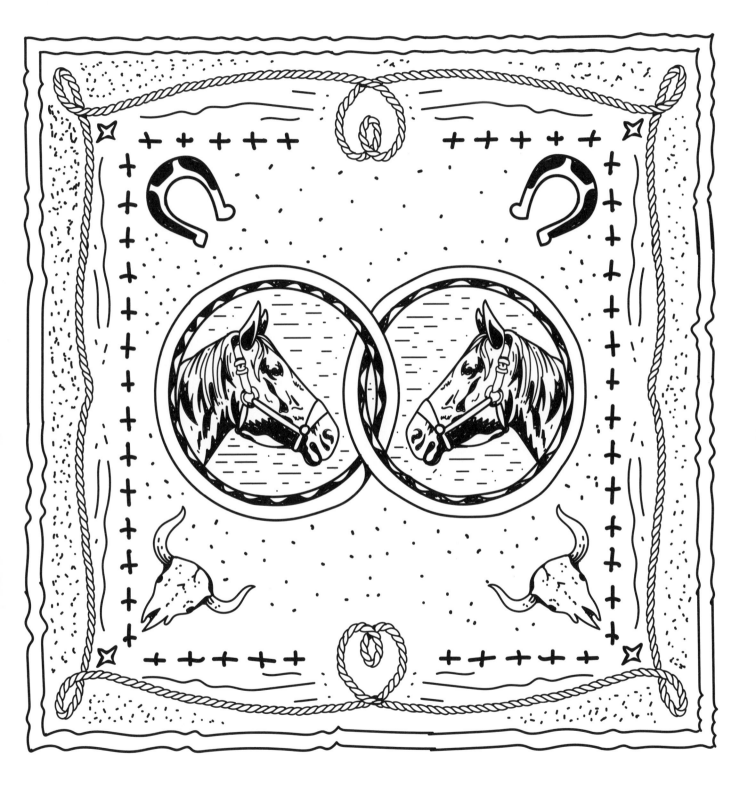

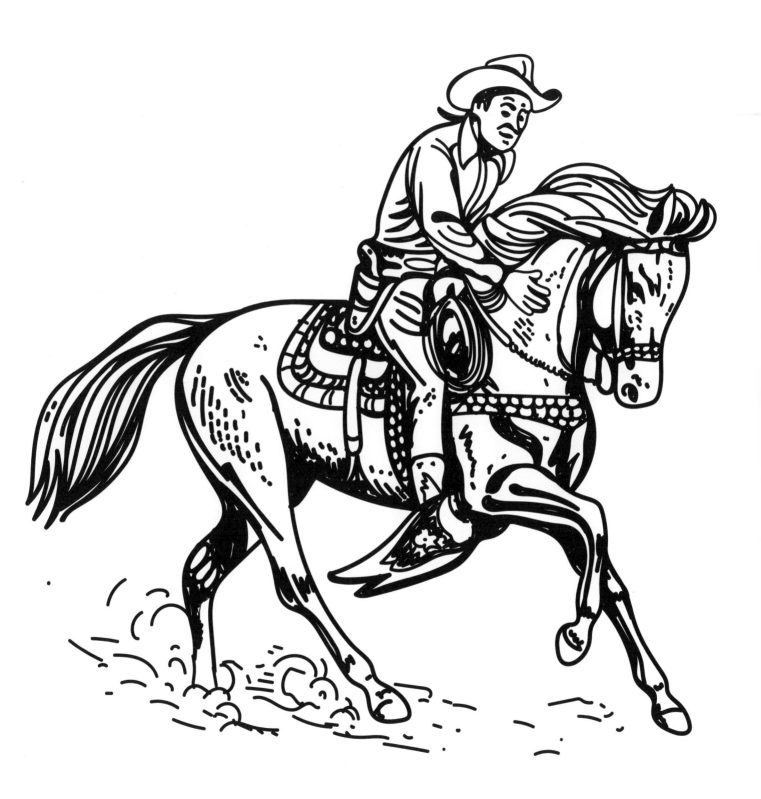

Quarto

© 2023 Quarto Publishing Group USA Inc.

This edition published in 2023 by Chartwell Books,
an imprint of The Quarto Group
142 West 36th Street, 4th Floor
New York, NY 10018 USA
 T (212) 779-4972 F (212) 779-6058
www.Quarto.com

10 9 8 7 6 5 4 3 2 1

Chartwell titles are also available at discount for retail, wholesale, promotional,
and bulk purchase. For details, contact the Special Sales Manager by email at
specialsales@quarto.com or by mail at The Quarto Group, Attn: Special Sales
Manager, 100 Cummings Center Suite 265D, Beverly, MA 01915, USA.

ISBN: 978-0-7858-4320-7

Publisher: Wendy Friedman
Senior Managing Editor: Meredith Mennitt
Senior Design Manager: Michael Caputo
Designer: Sue Boylan & Alana Ward
Editor: Caitlyn Ward
Image credits: Shutterstock

Printed in China